LANCASHIRE COAST

THROUGH TIME

Jack Smith

AMBERLEY PUBLISHING

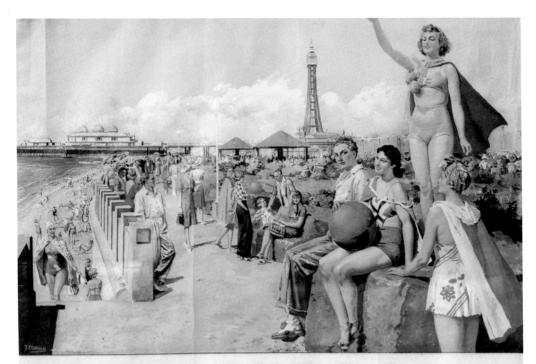

 BLACKPOOL

by Fortunino Matania R.I.

A Seaside Holiday in Blackpool

The famous Blackpool Tower and nearby Central Pier feature, as does the beach, each one of them being well-known attributes for this seaside town. This detailed poster was produced for the London & Midland Scottish Railway advertising campaign during the 1930s, and would have been seen on railway stations far and wide. The original painting was done by Fortunino Matania R. I., who was commissioned by other railway companies around the country. Many other well-known painters of the time also did railway posters. Today, the original paintings are very valuable.

First published 2013

Amberley Publishing
The Hill, Stroud, Gloucestershire, GL5 4EP
www.amberley-books.com

Copyright © Jack Smith, 2013

The right of Jack Smith to be identified as the
Author of this work has been asserted in accordance with
the Copyrights, Designs and Patents Act 1988.

ISBN 978 1 4456 0849 5

British Library Cataloguing in Publication Data.
A catalogue record for this book is available from the
British Library.

Typesetting by Amberley Publishing.
Printed and bound in the UK by CPI Colour.

Introduction

The County Palatine of Lancashire was established in 1351, the sovereign at the time delegating their wishes to an hereditary nobleman, the Duke of Lancaster. That title is held by the Queen today. The geographical county still exists but, for administrative purposes, a much-reduced Lancashire area now exists.

Adjacent are the new counties of Greater Manchester and Merseyside, both of which were originally in Lancashire. In fact, many occupants within these new administrative areas still regard themselves as Lancastrians, as evidenced by their use of 'Lancashire' in their postal addresses, rather than Greater Manchester or Merseyside.

The change came about during 1974. This meant that 'we' lost our major cities of Manchester and Liverpool, our seaside town of Southport, as well as a stretch of coast from Southport to Liverpool. In central Lancashire, we lost the large towns of Bolton in the south-east and Wigan to the south-west. In the far north, we lost what was always referred to as 'Lancashire Over the Sands', which is now in Cumbria.

Oddly, though, the River Kent, which seemed to many to have been the logical and definitive boundary between Lancashire and Cumbria, was not used. The imaginary boundary line is a few miles south of the River Kent, passing north of Carnforth and through Silverdale. At Arnside, a railway viaduct crosses the river, some 1,300 feet in length. This is the route for trains running to Grange, Barrow-in-Furness, and along the west coast, north to Carlisle and Scotland.

We still have the major towns of Blackburn and Preston (the later gaining city status in 2002), and the City of Lancaster, now famous for its university as well as its general history. Its great John O'Gaunt castle, historically one of her majesty's prisons (now closed), is currently undergoing improvements for the benefit of visitors. The courtyard is already open and the famous gate, which was always closed to non-visitors, is now open to the general public. It is overlooked by the imposing castle keep.

The coast of 'new' Lancashire now extends from Tarleton/Hesketh Bank in the south, on the River Douglas (or Asland), and runs north past Morecambe to Carnforth/Silverdale, with Arnside a few miles to the north but marginally outside Lancashire. However, for the convenience of writing, I will regard the River Kent as Lancashire's northern boundary (perhaps with some objections!).

Although not dealing with the east side of the county at this time, it is worth noting that this boundary is little changed, but to the south, the residents are still trying to establish where it runs exactly. This is probably why they still say they live in Lancashire!

As far as major changes within the existing county are concerned, it is the workplaces and transport features that seem to have changed so many of the scenes and landscapes over time, as well as land disappearing due to development in and around towns, both large and small.

Lancashire is fortunate in having good motorway routes north, south, east and west. However, there are still places where gridlocks are a regular feature: Lancaster, with its one-way system, giving access to the north and to Morecambe, where perhaps eventually a bypass route will be created; and Preston, where traffic from the west cannot cross the River Ribble to the Fylde without driving into and out of the town.

Lancashire's former 'bread-and-butter' industry, that of cotton goods manufacture and its machinery, has almost completely disappeared, along with the mills that produced it. Sadly, I have been witness to the loss of so many of the mills, but have photographed and recorded their passing where I could. Some mills are now divided into multi-unit enterprises, and others have been converted to offices and/or private dwellings.

Our canals, some now reopened, others yet to be reopened (Lancaster Canal northern end), provide a leisure activity for many. The Ribble Link allows canal boats to move from the Lancaster Canal north end, down to the Ribble and across to Tarleton via the River Douglas, and from the south end of the Lancaster Canal via Rufford and Burscough, then on to Wigan or Liverpool.

The county, though smaller, has lost none of its historical features. In fact, we have gained some, due to conservation work by many groups. The county is as varied and appealing as ever, with town features old and new, and a coastline with holiday resorts, glorious beaches, sand dunes and breathtaking scenery.

Jack Smith

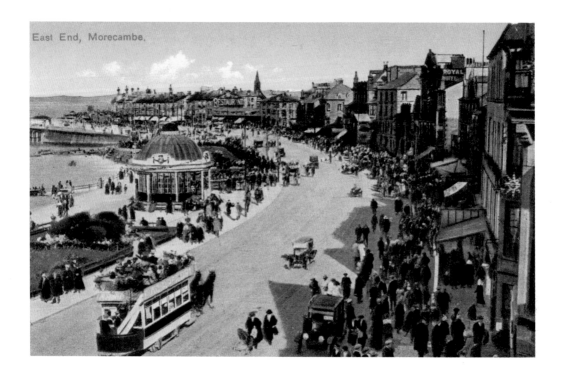
East End, Morecambe.

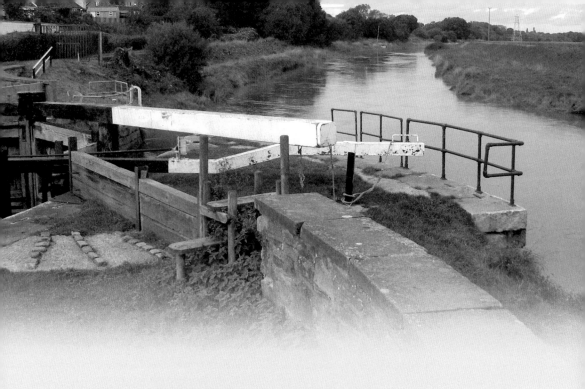

CHAPTER 1

River Douglas to
Ribble Estuary

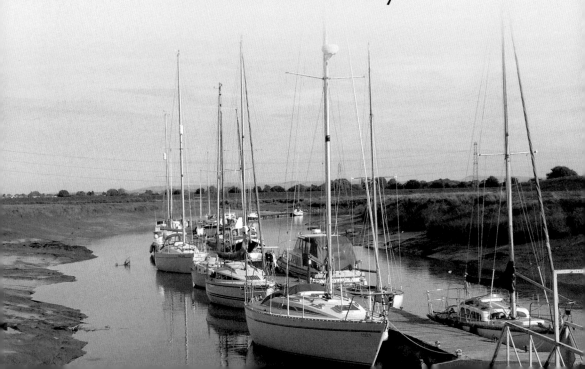

The River Douglas

The River Douglas has its source on Rivington Moors, and runs via Wigan to join the River Ribble. It is thought to have been used for navigation since the Roman times. The river was canalised during the nineteenth century before being superceded by the construction of the Rufford branch of the Leeds & Liverpool Canal, running from Burscough Locks to Hesketh Bank, where it locks into the Douglas. Here, boatyards and chandleries are to be found, with much scope for the photographer.

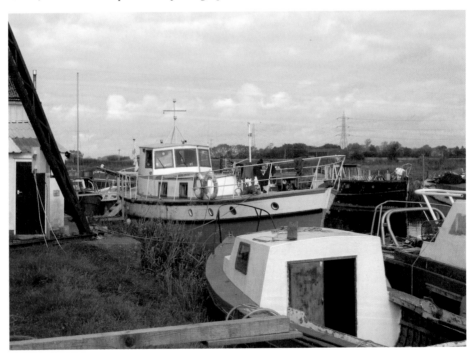

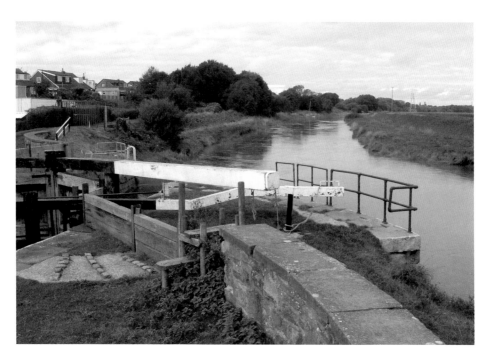

Tidal River

The River Douglas is tidal here and several feet high, and the lock gates, from the canal lock, can only be used at high tide. Today's view, in roughly the same location as the image below, shows the river outside the gate at almost high tide. The river is mainly used by pleasure craft nowadays, especially canal barges, which can cross the River Ribble to access the link system and continue north.

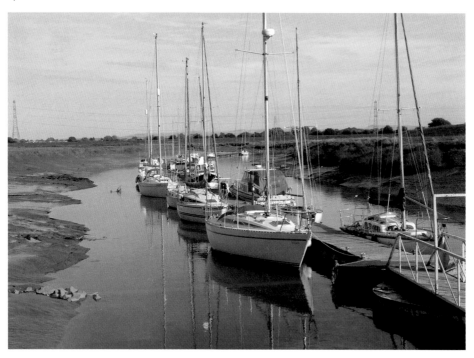

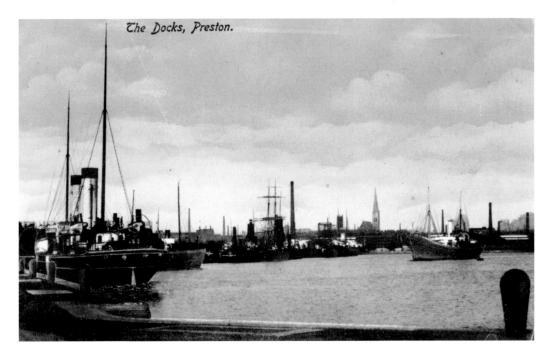

The Docks, Preston.

Preston Dock

Preston Dock is now a marina 10 miles from the Ribble Estuary. The deep river channels were quick to silt up and a dredger worked almost constantly to keep them clear. The river itself was rerouted prior to the dock's construction in the 1890s. The old image looks from the west end lockside into the dock, and shows ships tied up to the north side. In the middle distance is the spire of St Walburge's church. The modern image was taken from a similar position.

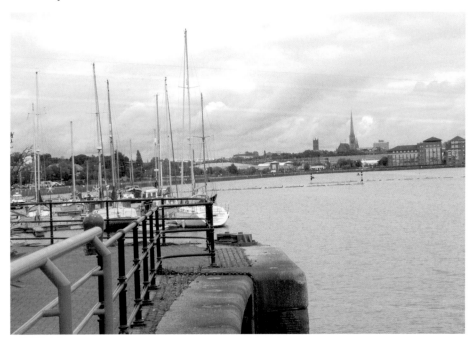

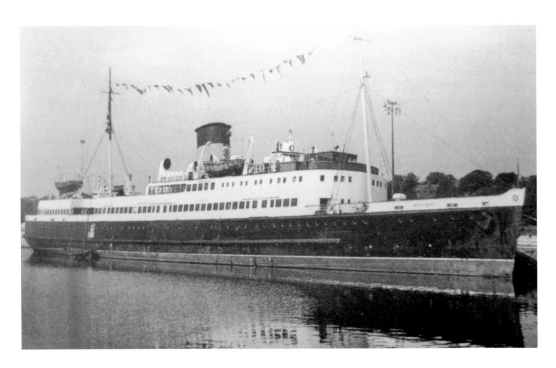

The *Manxman*

Moored on the north side of the dock is the Isle of Man steam packet vessel, *Manxman*, launched in 1955. I travelled on her several times and knew the engine room well. Her last voyage was in 1981. Later, she sailed into Preston Dock, becoming a resident feature. But it was too early as commercial, residential and leisure development had not taken place, and she was towed away and ultimately scrapped. She was the last steam turbine ship to be used on the cross-sea route, and starred in several films. Today's view shows how the *Manxman* gave way to development.

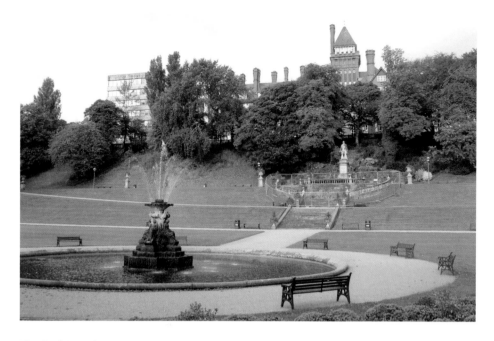

The Park Hotel

Preston was important in the development of the railway system to the north. The station saw several railway companies using it jointly, and a hotel was built conveniently close to the station for passengers in transit as well as visitors, with a covered walkway running from a station platform to the hotel itself. The imposing structure faced southwards, overlooking Miller Park. The old view shows the Park Hotel on its high eminence. Today, the former hotel is used as office premises, and is largely hidden by trees.

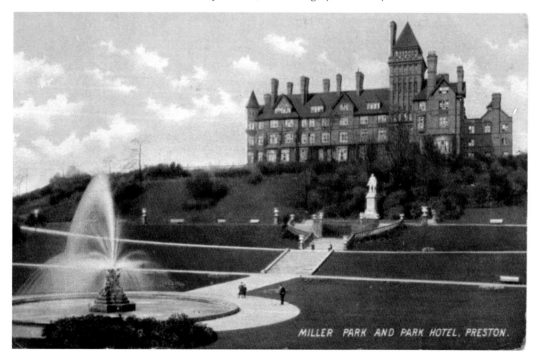

MILLER PARK AND PARK HOTEL, PRESTON.

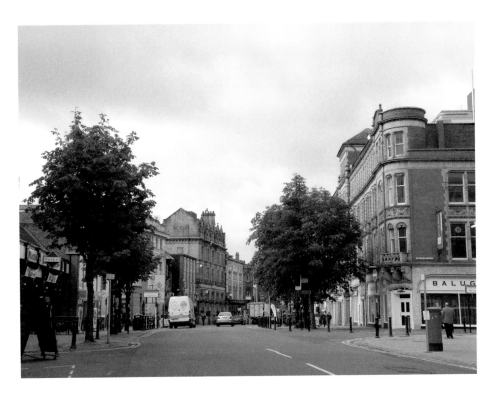

Shopping in Preston

While having a brief look at Preston, which was a port indirectly on the west coast of Lancashire, we look at some of its interesting buildings. Here, we look from Church Street into the main shopping street of the town, Fishergate. To the right is the 1899 Miller Arcade building as it used to be, and it is more or less unchanged today. Beyond it was the Sir George Gilbert Scott Town Hall, which was destroyed by fire in 1947. By public demand, the lower part of it was stabilised and it continued to be used until its demolition in 1962.

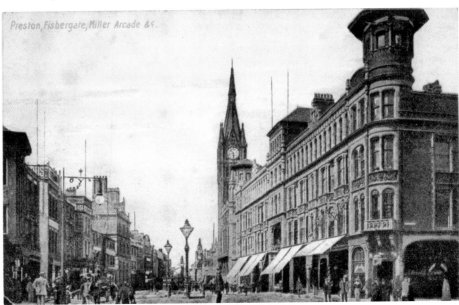

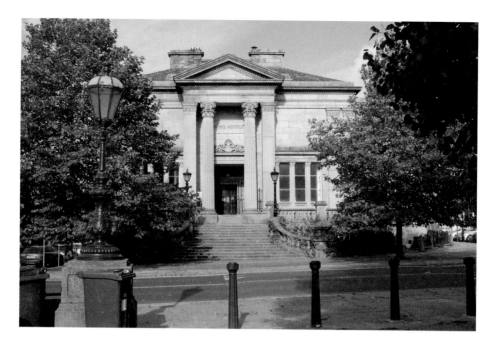

The Harris Institute

Another interesting building is located at the south end of Winckley Square. Originally called The Institute for the Diffusion of Useful Knowledge and dating from the mid-nineteenth century, it is located close to Avenham Park. Later, this building became the Harris Institute. It is soon to become an Islamic school for boys. The square with its central tree-covered area, surrounded by Georgian buildings, is a must visit if architecture is your thing. The older view dates from around the 1860s. Today's image, with its autumn tinge, softens the classical lines of the old view.

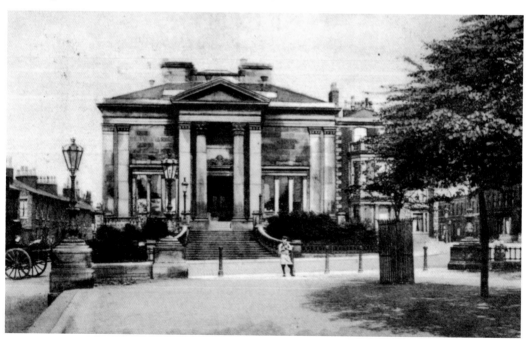

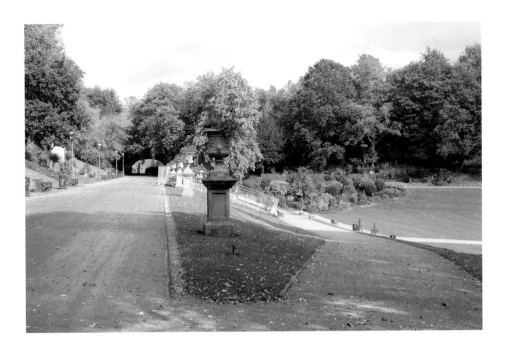

Miller Park

Adjoining Miller Park is Avenham Park. To the north is the high ground where both of our previous images are located, while to the south of the park is the River Ribble. Footpaths and views are numerous: here we look to the east along the higher ground to the front of the previously mentioned Park Hotel. The flower containers are still in place, and in the centre of this walkway are steps upwards, and down to a lower level. Atop the steps is a statue of the Right Honourable Edward Smith Stanley, MP for Preston, 14th Earl of Derby and Prime Minister from 1866–68.

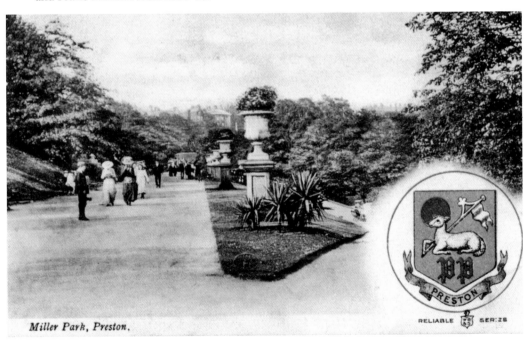

Miller Park, Preston.

RELIABLE SER:25

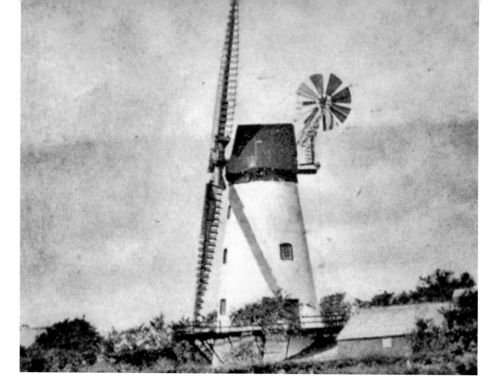

Clifton Village

Moving down river now towards the River Ribble Estuary, we pass the new canal link (opened 2002), created by widening Savick Brook to our right (the north bank), and come into the area of Clifton, so named after the past local Lords of the Manor hereabouts. Clifton is a small village, now bypassed by the busier Blackpool Road. Clifton's eighteenth-century tower windmill has been preserved and converted into a popular hostelry, as shown in the current view. Close to this mill is the former Salwick (now Springfields) manufacturing site for atomic reactor fuel rods.

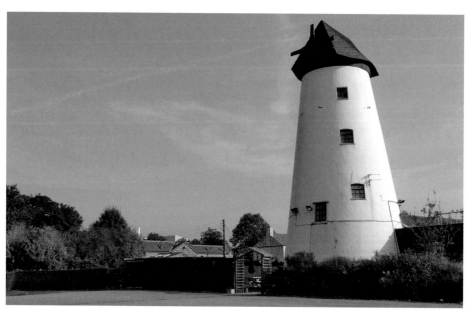

Freckleton Air Disaster

We next come to Freckleton, where boatbuilding, rope making and sailmaking once took place. Today, the village is known for the 1944 disaster in which an American plane, a Liberator, crashed into the village infants' school, killing sixty-eight people, more than half of them children, plus teachers, civilians and aircrew. The old view is from that crash, and shows the damaged school. Today, a plaque (under the street name) commemorates that event. All who died, except aircrew, are buried in one grave, as shown in the inset.

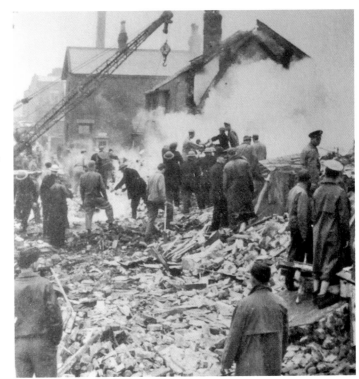

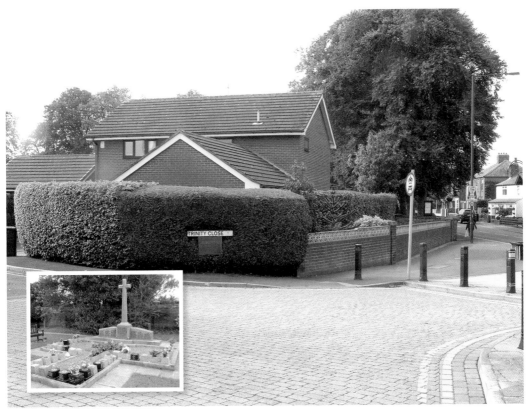

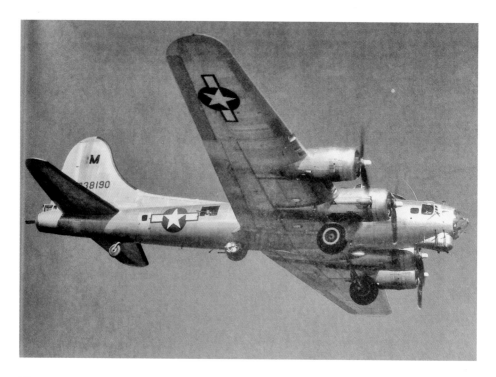

Warton

The adjacent village of Warton saw construction of a small RAF base in the late 1930s/early 1940s, under Blackpool's aerodrome staff. In 1942, the USAAF took over the site, and for the next three years some 20,000 US aircrew established a huge base where planes from the USA were assembled, and damaged planes were repaired and returned to their respective bases. Our old view shows a B-17 Flying Fortress on a local test flight. Today, Warton is one of BAE's production facilities for the Typhoon or Eurofighter plane.

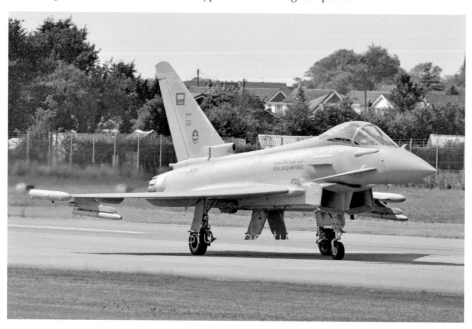

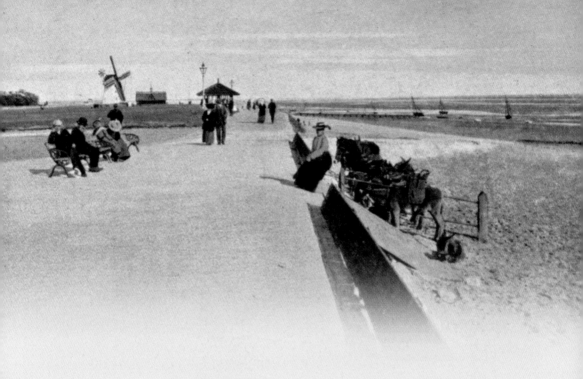

CHAPTER 2

Lytham &
St Annes

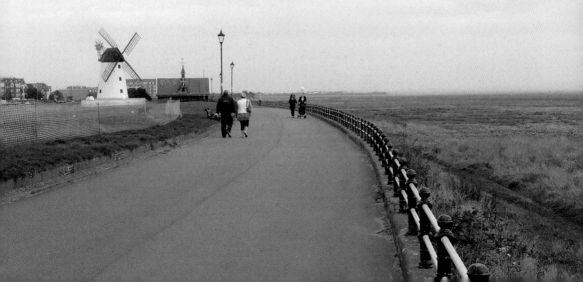

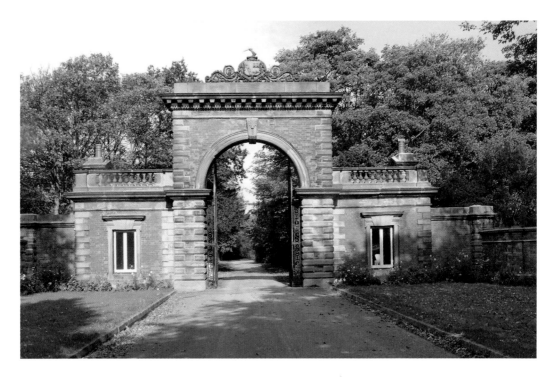

Lytham Hall Gateway

This fine gateway entrance to the pleasure grounds of the hall itself appears to be one in which a gatekeeper lived, for at the side of the gate are small rooms, probably a one-up, one-down lodge. Outside are a small washhouse and a privy. The gateway arch is brick-built, with the family coat of arms above the centre. The estate covers a large area, so it is likely that there were other similar gates. But this is the gate nearest the township of Lytham to be seen by residents!

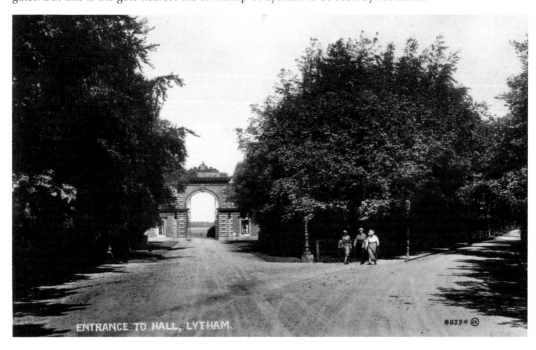

ENTRANCE TO HALL, LYTHAM.

89394

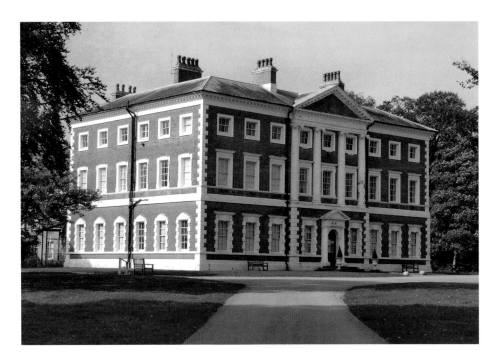

Lytham Hall

The home of the Clifton family from the eleventh century, it was in family occupation until the 1930s when the squire, John Talbot Clifton, traveller and adventurer, who hardly ever lived at the hall, bought a castle on the Isle of Islay to live in. The present hall, with its classical Georgian exterior, was built in the eighteenth century by the family. It eventually passed into the ownership of the local authority, along with a magnificent park. Today, the hall is open to the public at limited times.

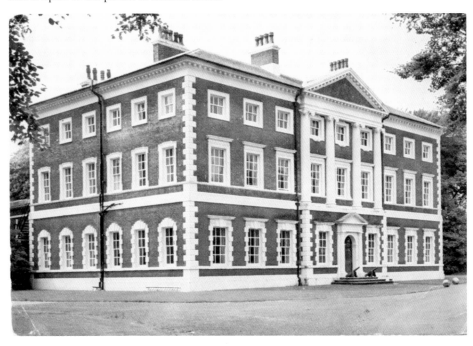

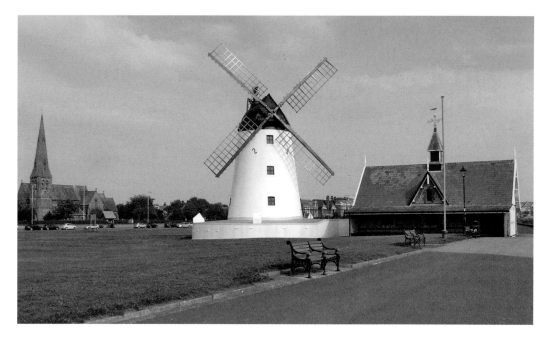

Windmill by the Sea

It is appropriate that the town of Lytham celebrates its windmill history; the first wooden mill in Lancashire was sited within the hall grounds in the twelfth century. The present tower mill dates from 1805, and has seen several major repairs due to fire, storms, etc. The mill was last worked by Mr Swann, who was miller there for twenty-five years, until a devastating fire destroyed most of the wooden machinery in 1919. After some time of disuse, it was refurbished as a museum. Nearby is the original lifeboat station for the town. A new station with state-of-the-art electronics and boats has been built a short distance away.

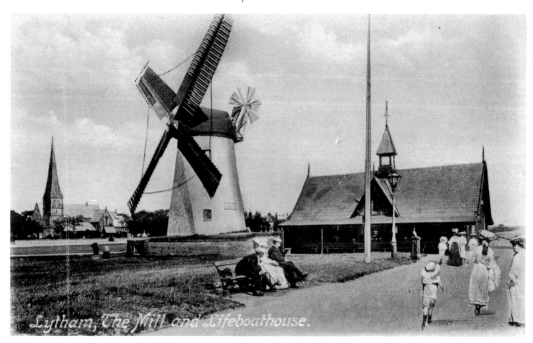

Lytham, The Mill and Lifeboathouse.

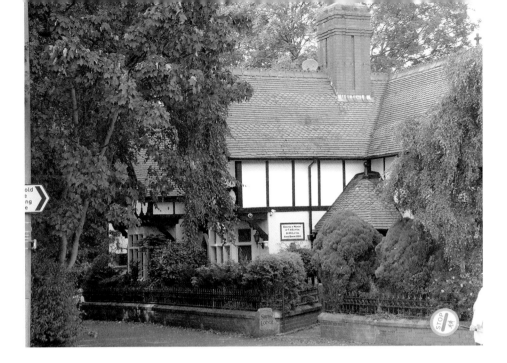

Swiss Cottage

Swiss Cottage, as the building is called, lies to the north of the town. It was built in the Elizabethan style with timber panelling, but it dates from 1913. There is a plaque by the front door stating that the house was 'Erected in memory of T. H. Clifton by M. Clifton, ANNO DOMINI 1884'. Due to its location, with the long Green Drive running alongside the property, it would suggest that it was another gatehouse originally, which was later extended into a dwelling.

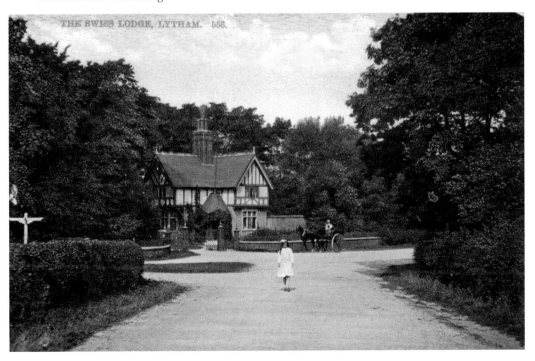

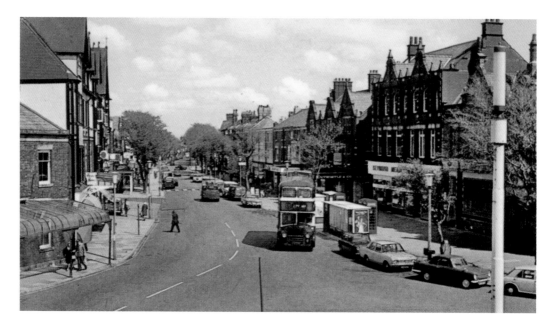

Visitors to Lytham

Our old view shows the west end of Clifton Street, the main shopping street. Close by are the railway station, a heritage centre, and the large open space of Lytham Green, with its windmill facing over the Ribble Estuary, and Southport easily visible in the distance to the east. The green plays host to the annual Lytham Proms, featuring top artists. Clifton Street has an interesting array of shops, plus many cafés. In October 2013, Lytham won gold in the 'Britain in Bloom' competition, and was named 'Champion of Champions' by the RHS for its delightful floral decorations.

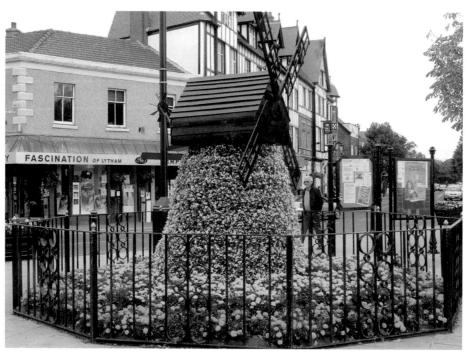

Exploring Lytham

Shoppers feature in the two views here. In fact, the pavements seem a little too narrow for pedestrian traffic sometimes. Apart from the variety of shops fronting the street, some with canopies in front, there are also narrow alleyways to explore. While exploring the streets around the town centre, make sure to look up and see some of the interesting architecture. Side streets towards the green have pebble decorations in the footpaths.

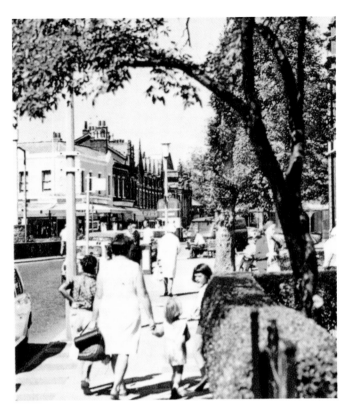

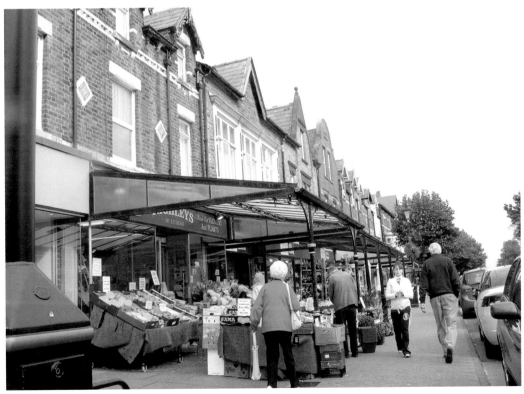

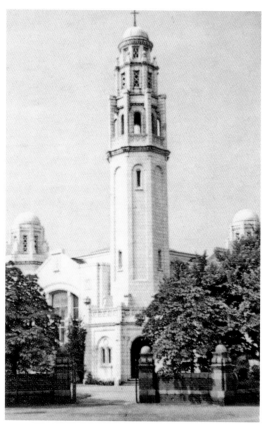

'The White Church'

'The White Church' stands alongside Clifton Drive, which is the road from Lytham to St Annes. Its full name is the Fairhaven United Reformed church, but it was Congregational until 1972. In 1899, the Lytham Congregationalists proposed that a new church should be built, as the population was rapidly increasing. The church was so successful in raising the half a million guineas needed for the enterprise that the new church was opened on 17 October 1912, built on land leased by the Clifton family. The architects were Briggs, Wolstenholme and Thornley of Blackburn, and their unusual Byzantine-style design, faced with white-glazed tiles, quickly became known as 'The White Church'. It is an outstandingly beautiful church, and perfect for wedding photographers. It is a Grade II* listed building.

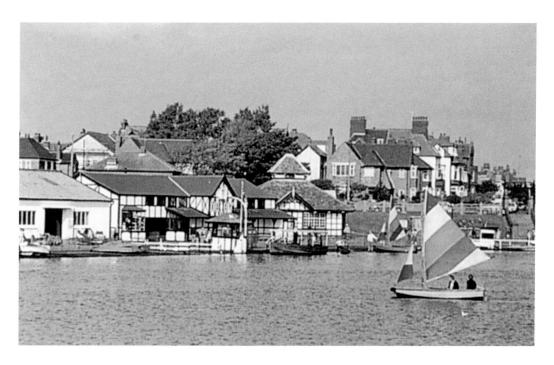

Fairhaven

Moving west along the north shore of the Ribble Estuary, we arrive at Fairhaven, located between Lytham and St Annes, close to the shore with its beach and sandhills. Separated from the shore by an embankment is a lake with islands. Here, boating activity is an attraction. Adjacent is a bowling and tennis facility, plus picnic areas, cafés and shops. Birdwatching is another popular activity. With marsh flats on the seaward side and the lake providing a more sheltered area, it is favoured by many bird species.

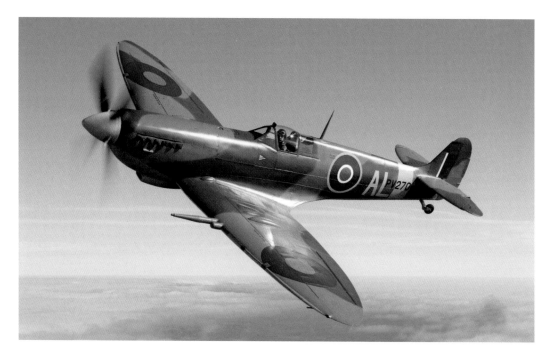

Lytham's Spitfire

A splendid addition to the Fairhaven Lake complex is a full-size Spitfire aeroplane (W3644). This replica is affixed to a single support, which fastens to the underside of the plane, some 30 feet in the air, so that all its markings are visible, as is the pilot who had local family connections. The replica commemorates Lytham's fundraising in 1941 to buy the real plane. It is also a memorial to the pilots who served during the war.

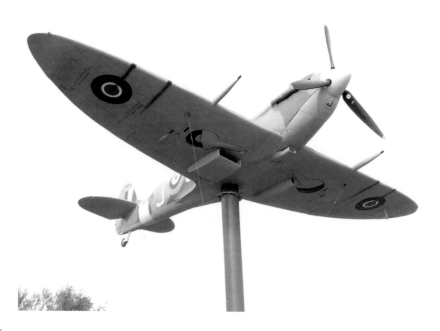

THE LAKE FAIRHAVEN. THE SQUARE

RUSTIC BRIDGE, ASHTON GARDENS. THE PIER

SOUTH PROMENADE. ASHTON GARDENS.

STEPPING STONES, PROMENADE GARDENS. CORNER OF SWIMMING POOL

THE SPEED BOATS. LILY POND, PROMENADE GARDENS.

St Annes

A half mile past the Fairhaven Lake we arrive in St Annes, which has many interesting terraces of private houses dating from the Edwardian era. Its wide main shopping street can rival many towns, and the pavement coffee culture is very obvious. St Annes' promenade features gardens, children's attractions, sands and a pier, which is now enclosed and contains children's rides and games, and a café. The old and new postcards illustrate the variety of attractions St Annes has to offer.

St. Anne's on Sea

ST ANNES PIER BOWLING RESTA

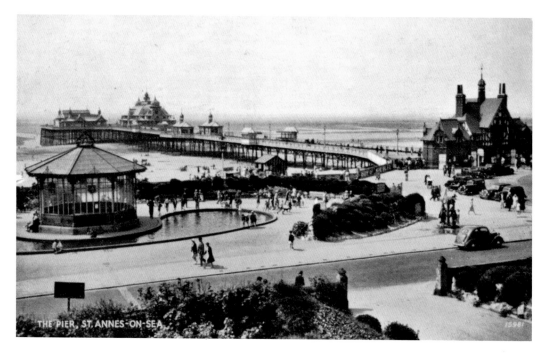

THE PIER, ST. ANNES-ON-SEA

The Pier

St Annes Pier opened in 1885, and was over 900 feet long. A jetty at the end of the pier in 1891 allowed ships to tie up and take passengers to Blackpool and Liverpool. A mock Tudor-style entrance was built in 1899. Subsequent alterations saw the construction of new buildings and facilities, such as the Moorish Pavilion (1904), and a Floral Hall (1910). Both of these were lost in separate fires in 1974 and 1982 respectively. The pier was reduced in length following the fires. The pier is a Grade II listed building.

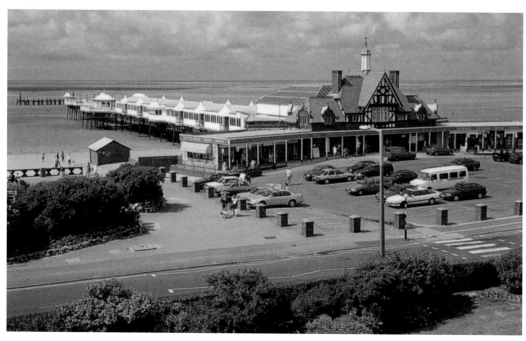

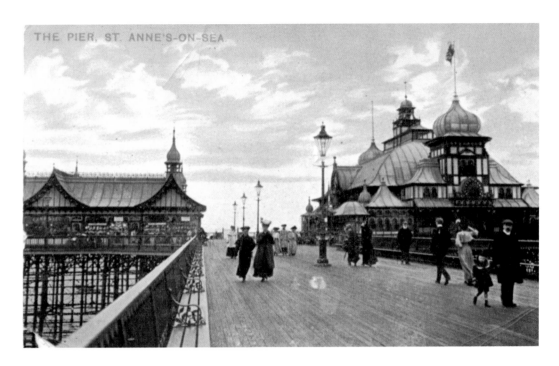

Pier Pavilions

This old view looks to the seaward end of the pier. It shows the entertainment pavilions as they were in 1909, when the old postcard image was postmarked. The building to the right is the 1904 Moorish Pavilion, reported as being one of the best pier buildings in England. To the left are buildings that appear to be shops. It was in this area that the Floral Hall would be built in 1910. Today, 150 feet of open pier remains, as seen from the end of the enclosed amusement arcade.

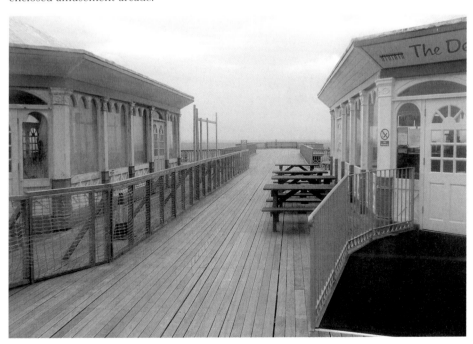

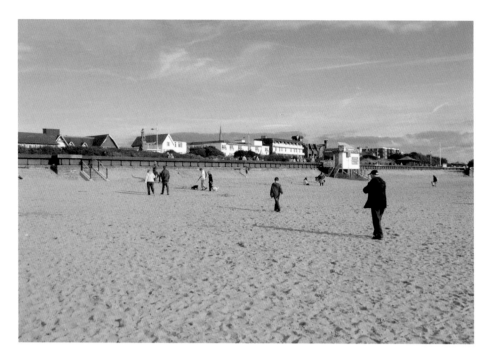

Sand and Castles

The beach at St Annes is sandy, the tide coming in almost to the sea wall, and it is most suitable for sandcastle building and shell hunting, as well as paddling. Donkey rides are to be had, as well as refreshments. The sands extend a great distance each side of the pier, and on the north side there are extensive sand dunes between sea and promenade. Another favourite with children at times is the visiting bouncy castle and slides.

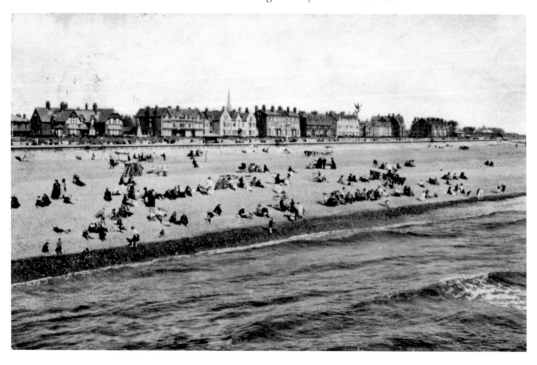

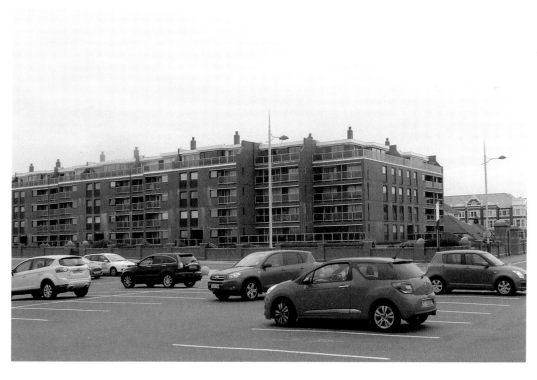

Old and New

With the passing of time, it was necessary to replace some of the earlier buildings for the sake of modernisation and/or redevelopment generally. St Annes has had many of its old buildings revamped for new businesses or shops. Most of these changes, and the juxtaposition between old and new, work very well. One building that was demolished was the Imperial Hydro, which stood opposite the pier entrance. This is currently being replaced by a new building.

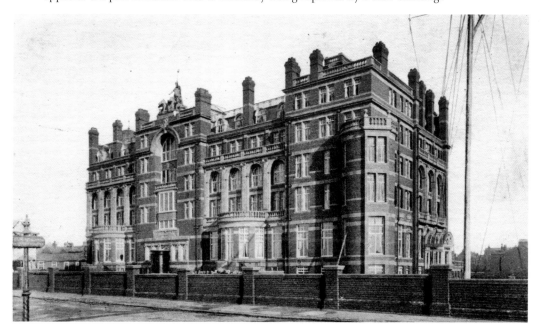

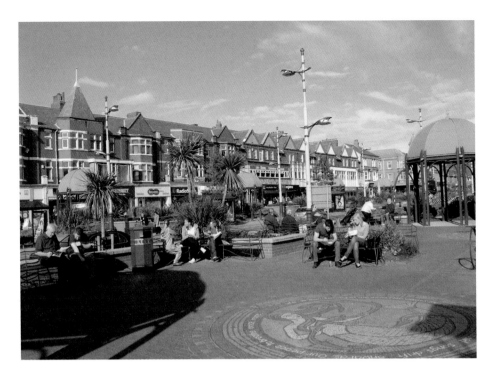

Street Ornamentation

The main street of the town between the rows of shops is very wide, and is even referred to as a square. Its footpaths, created years ago, now accommodate metal sculptures and pavilions, while on the ground there are various artworks in the form of mosaics. Older buildings in the street are worthwhile examining to compare how the new has fitted in with the old. Oh, and the pavement cafés are popular places to sit and watch the world go by.

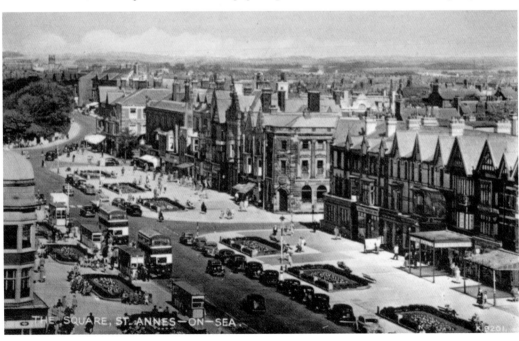

THE SQUARE, ST. ANNES—ON—SEA.

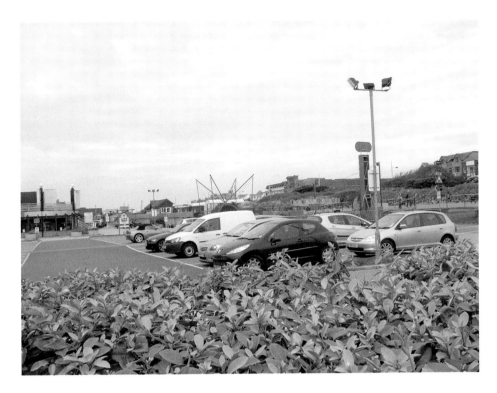

Enjoying the Sunshine

Returning to the seafront promenade, the older postcard shows us there was an outdoor swimming pool here, and it looks like it was a warm day when the image was recorded! Today, this same location is covered by a car park. The only thing visible in both images is the roof of the pier entrance, about an inch in from the left-hand side of the old image. Even the church spire is no longer visible, as buildings have obscured it.

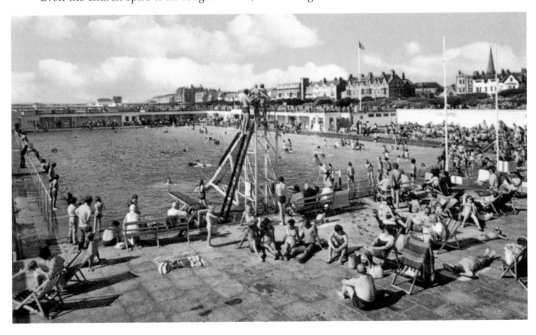

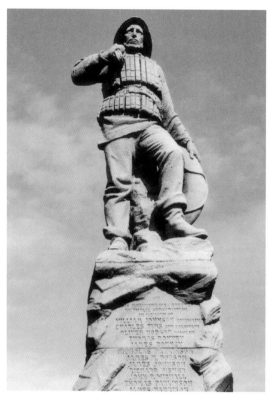

Lifeboatmen Memorial

On St Annes' seafront, looking out to sea, this memorial statue commemorates the loss of life during a bad storm on the night of 9 December 1886. That night, off the coast of Southport, some 4 miles across the River Ribble Estuary, a German barque (the *Mexico*) was having difficulties. Lifeboats went out from Southport, Lytham and St Annes to help, rowing in terrible conditions. All the St Annes crew lost their lives, as did all but two from the Southport boat – twenty-seven men in total, and all are named on the memorial. The men aboard the *Mexico* were saved by the Lytham lifeboat. The barque was subsequently towed to a mooring off Lytham, refitted and put to sea again. The memorial at St Cuthbert's church in Lytham commemorates the loss of the men of the RNLI lifeboat *Laura Janet* on that dreadful night.

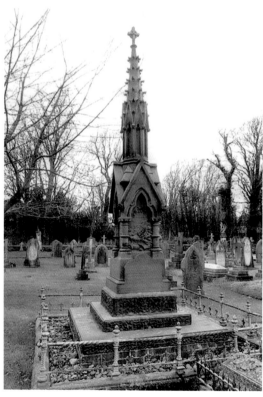

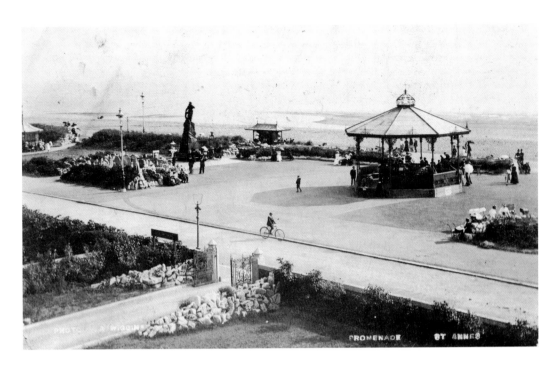

Looking Seaward

Viewed from the upstairs windows of St Annes' town hall on the promenade, the old postcard view looks across to the beach, with the *Mexico* memorial statue visible to the left, and a shelter to the right. As it is not possible to obtain the same view today from the same location, I thought a view in the opposite direction would be of interest. As such, the modern image incorporates elements of the old. Notice that the only vehicle in the 1908 image is one bicycle. Today, the promenade traffic is very different!

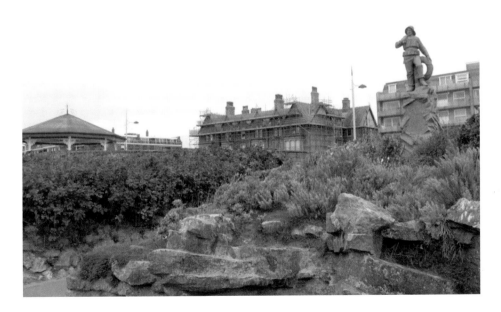

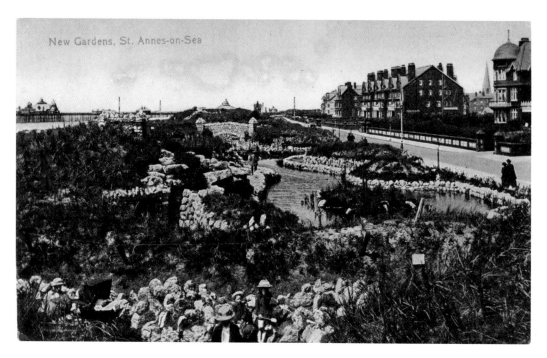

New Gardens, St. Annes-on-Sea

Flower Gardens

The gardens between the beach and the promenade roadway extend for some distance. They are in the form of rockery garden at the south end, with large limestone blocks forming cascades, grottos, a waterfall and stream/pond feature, with a bridge over the water. Ducks seem quite happy there, despite being a few yards from the passing traffic and flowerbeds intersperse the rock features, as does a mini-golf course. This view is looking north.

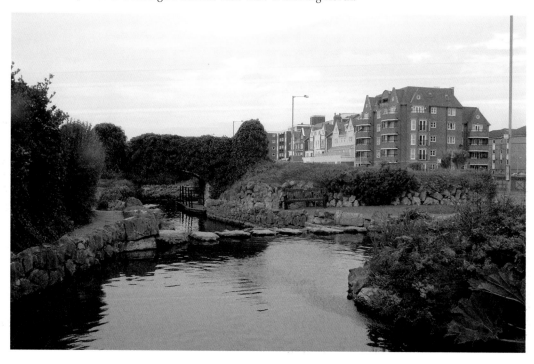

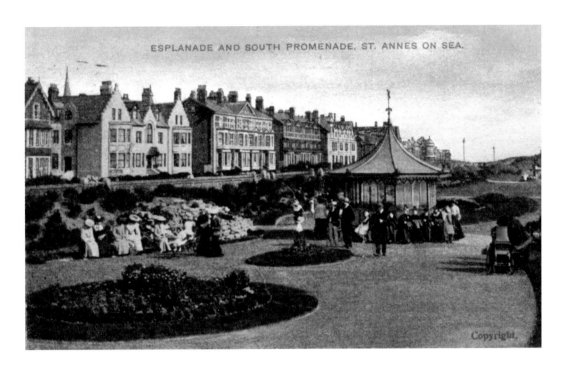

The Promenade

At the northern end of the rockery feature, looking north towards the pier, are lawns and flowerbeds. It is a nice place to sit and relax, and to enjoy one's ice cream perhaps, for benches are plentiful. Summer house-type shelters are located here also, as is a children's paddling pool and bandstand. Work is currently being undertaken to replace the flowerbeds, and also replace the normal stone slabs with limestone, to match the rockery.

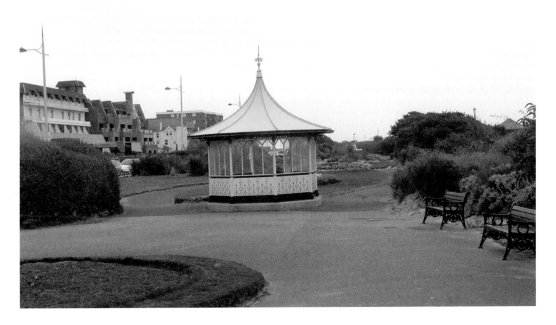

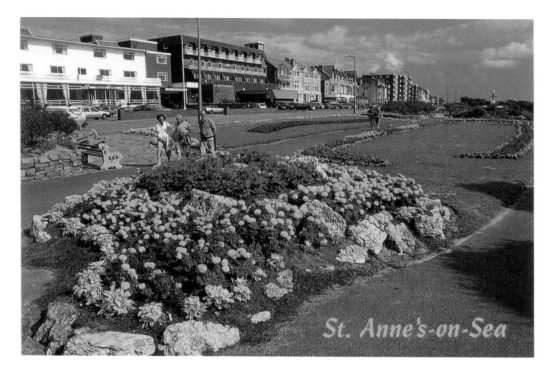

Sit and Relax

In this last look at St Annes promenade, I use two views of the flowerbeds and lawns at the north end of the promenade. The location is as described in on page 37, but the two views look in opposite directions. In the above image, we look south back towards the rock gardens, and in the lower image we look north, the roof of the pier entrance being visible at the upper left. Note the use of limestone in the flowerbeds.

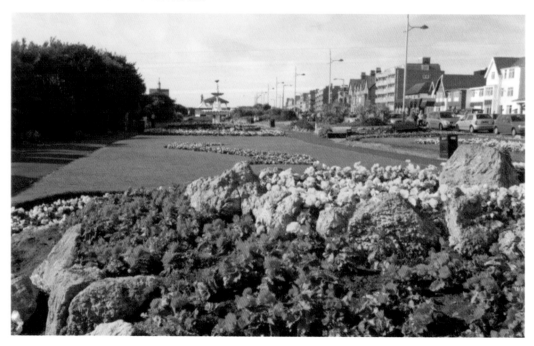

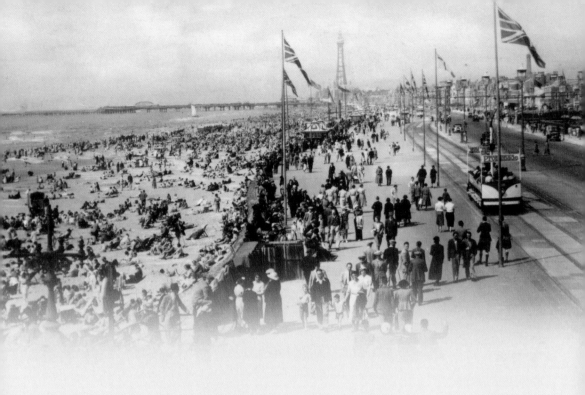

CHAPTER 3

Blackpool Promenade

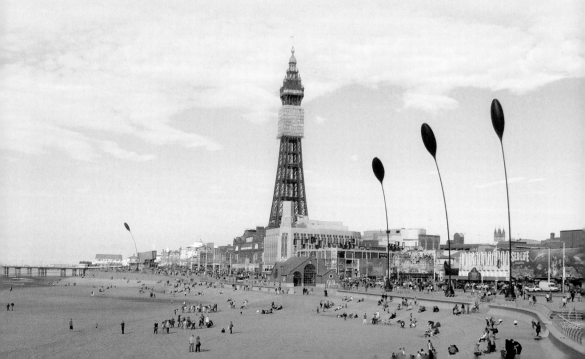

Blackpool South

Entering Blackpool from the south (South Shore) and close to the sea wall is a new tram depot, Starr Gate, purpose built for the new tramway system. Across the road is the tall structure of 'The Big One' big dipper, in the Pleasure Beach complex. The promenade from the new sea wall is very wide, with a separated tramway. Keeping to the sea wall side, we arrive at the site of the open-air baths, replaced by the Sandcastle complex. Its name is now the Sandcastle Water Park, allegedly the UK's largest indoor water park.

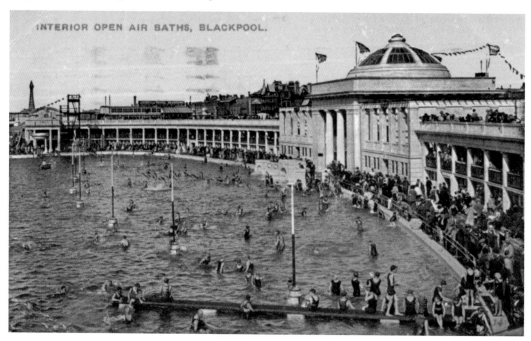

INTERIOR OPEN AIR BATHS, BLACKPOOL.

South Pier

Slightly further north we arrive at the Victoria Pier, as it was originally called, seen in the old view. It was opened in 1893, and its Grand Pavilion opened later in the year. It was renamed South Pier in 1930, and described as being a 'pleasure pier'. In 1938, the frontage was rebuilt with a new Regal Theatre. In 1964, the Grand Pavilion was lost through fire, and the Regal became an amusement arcade. Today, the pier boasts many roundabout rides and entertainments.

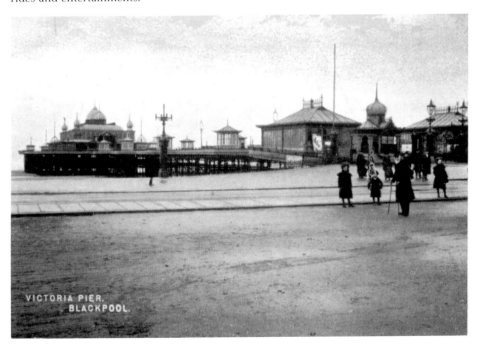

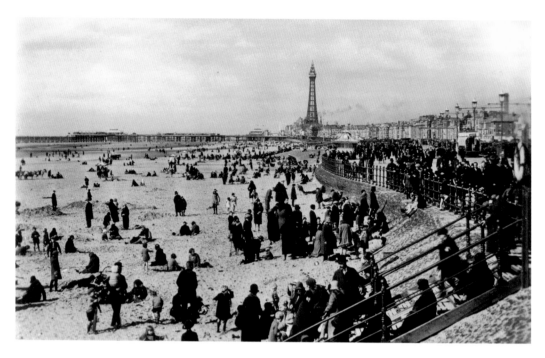

The Beach

From the South Pier, we look onto the beach as it was probably in the 1920s, in the days when there were no sports clothing or beachwear. Suits and Sunday best were the norm to wear on the beach or on holiday, and hats and caps were also essentials. Note the sea wall of the time as built in the early 1900s, which has greatly changed over the past decade to create a wider footway, and a curving sea wall along the promenade.

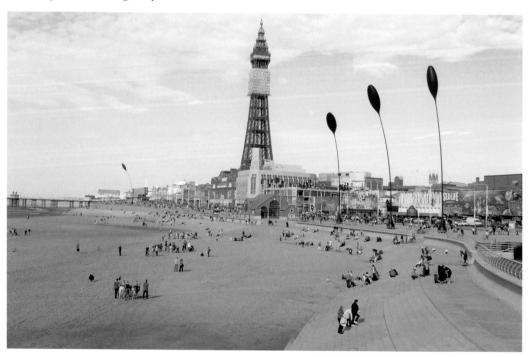

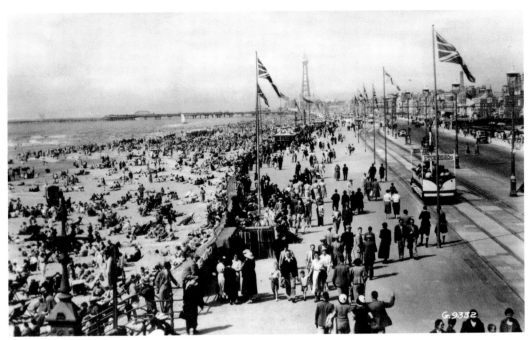

Holidaymakers

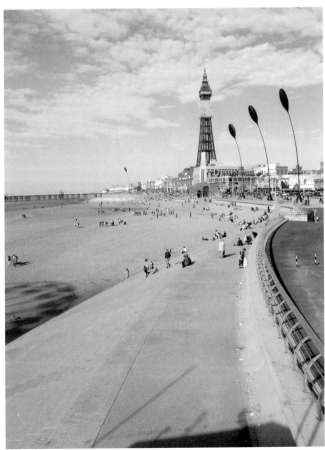

This view is from a similar location to the previous image, but looking more towards the roadway of the promenade. Apart from the crowds of people, and minimal traffic on the road, note the separate tramway and tracks. Never fully fenced in, it has proved to be a safe arrangement for pedestrians, although some fatalities have occurred. It was due to this separate tramway, set apart from the road, that trams continued to be used in Blackpool when all the towns in Britain had scrapped their systems.

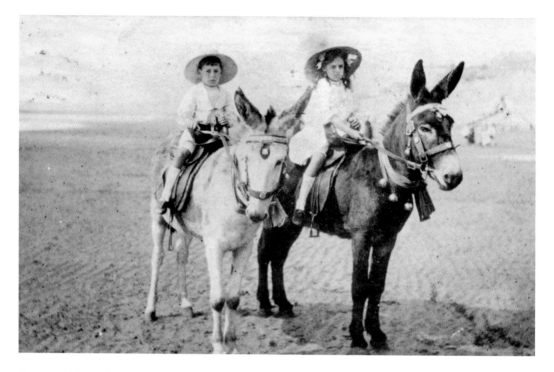

Donkey Rides, Of Course

For the industrial masses of Lancashire and beyond, donkey rides have become synonymous with Blackpool, and they're not just popular among children either. This old view of children riding dates from a postcard sent to Wigan in 1917, although the children seem a little apprehensive. Today's image was taken in late September 2013.

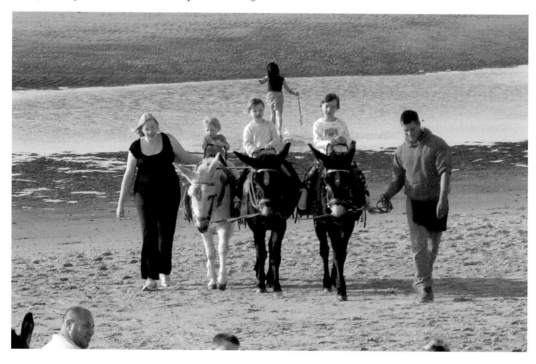

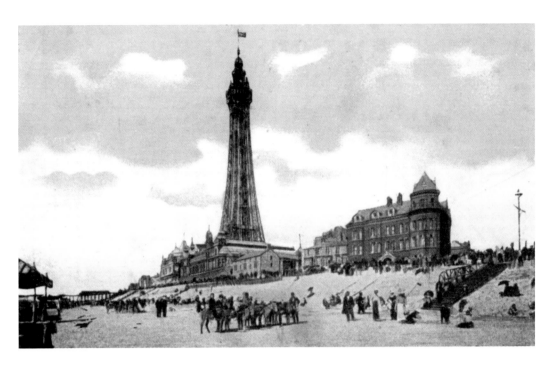

The Tower

This old view, looking at Blackpool Tower and the buildings of the time from the south promenade, shows us what was here in 1904. The tower itself opened in 1894. From that date until the completion of the Post Office Tower in London it was the tallest building in Britain at 518 feet. The nearest building, to the right, was the Palatine Family and Commercial Hotel. Next door, toward the tower, was the Royal Hotel.

Central Pier

The 1906 old view here shows the front of Central Pier. The contrast between the old image and that of today illustrates the difference in building trends then and now. It is surprising to see how many piers across the country have their pavilions embellished with domes similar to Eastern-style buildings. Perhaps this was something to do with the Empire at the time! Central Pier was the original South Pier, named as such before the present South Pier (originally Victoria Pier) was built.

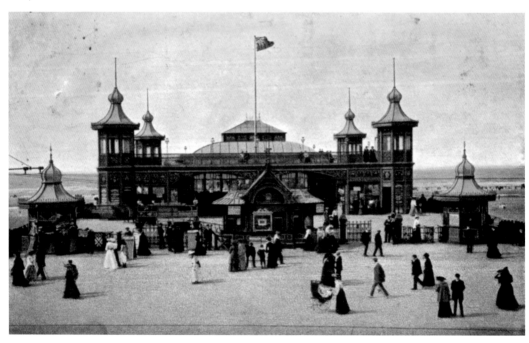

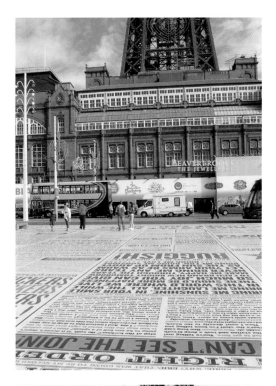

The Comedy Carpet

In front of the Tower building, the promenade was widened considerably during the 2009 regeneration of the sea front. This area is referred to as the Tower Headland, and extends out in a curve to occupy part of the beach sands. On this headland a fascinating work of art has been created: the Comedy Carpet. This is a celebration of comedy, with jokes, songs and catchphrases dating from the early variety music hall days to the present from over 1,000 entertainers. They made us laugh, and many of them performed in Blackpool. Today, there are so many phrases on the carpet, it even has its own guidebook! The old image from the 1950s shows the young comedians Morecambe and Wise on the beach, approximately where their jokes (i.e. 'can't see the join') are depicted on the carpet today.

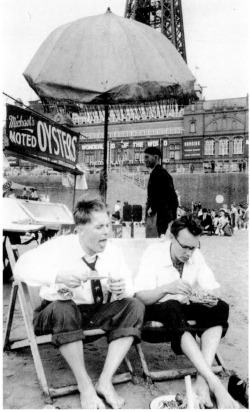

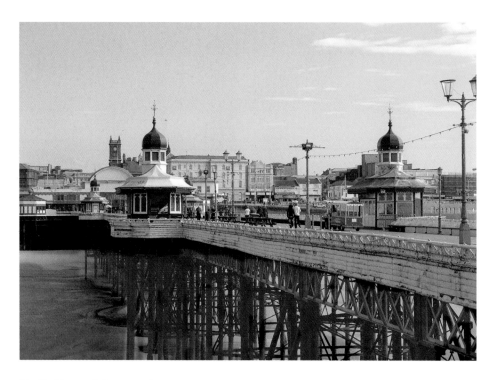

North Pier and Promenade

This view from the North Pier comes from a postcard dated 1919. We look back over the pier to the north promenade, where the Gigantic Wheel is very obvious. This was built in the mid-1890s, and was 220 feet high. It held thirty people in each of its thirty cars. Its weight was in the region of 1,000 tons. The wheel was dismantled in 1928. North Pier was regarded in its early years as the place where the upper-class visitors would walk sedately. However, its popularity soon ensured the pier was enjoyed by all.

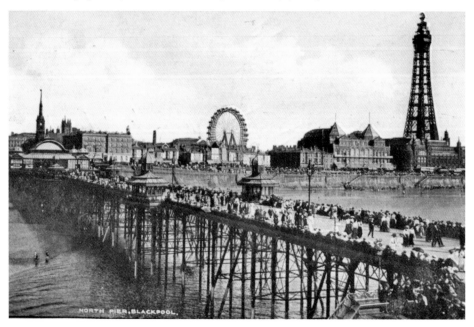

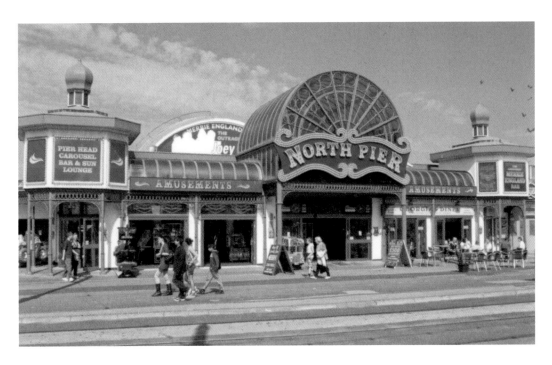

Sea Wall Elegance

The sea wall, as we come to the North Pier, has been much improved by adding curves, as well as the Spanish steps leading down to the beach sands. Its frontage shown on this 1940s image is much changed since opening in 1863. In 1867, the pier was damaged by Nelson's flagship, the *Foudroyant*, breaking loose from moorings. Between the 1870s and the 1930s, pavilions and theatres were built, some being lost to fire. In 2011, a major restoration project to restore the pier to its Victorian origins began.

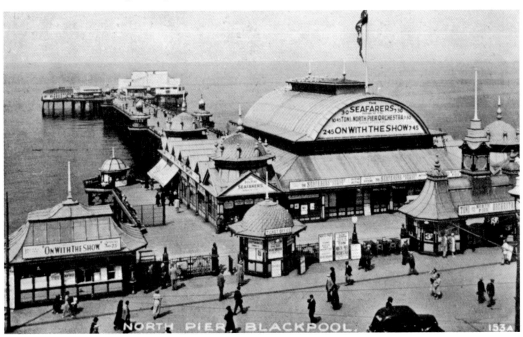

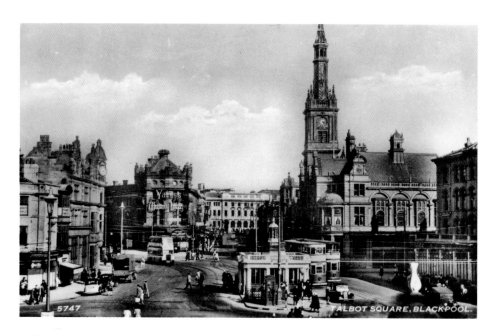

Talbot Square

Opposite North Pier is Talbot Square, with many interesting buildings, some now rebuilt. At the left of centre in the old view is, according to its signage, Yates Wine Lodge, located at the junction of Talbot Road (*left*) with Clifton Street (*right*). The lodge was originally the Talbot Road Assembly Rooms, which was opened in the late 1860s and later incorporated a theatre and library. A successful wine shop business, run by Messrs Yates on the Talbot Road side, eventually took over the whole building. The building caught fire in 2009, and was subsequently demolished. Today, the site is due to be redeveloped.

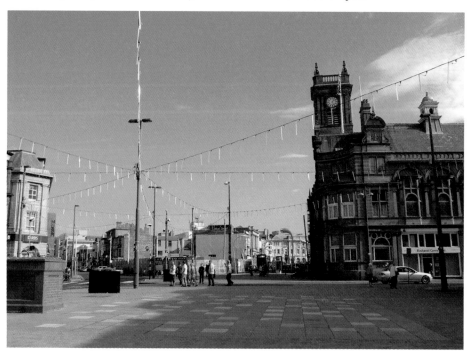

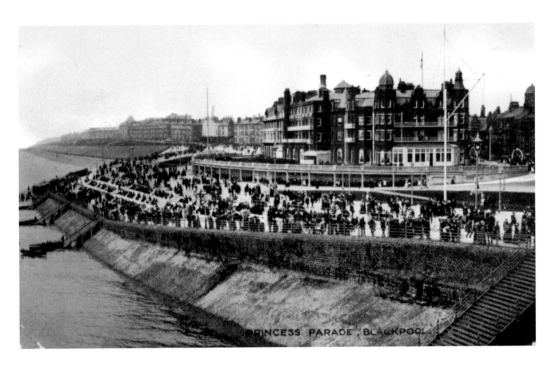

Grand Metropole Hotel

Just beyond North Pier is the present Grand Metropole Hotel. In the old view, we are looking from the North Pier. This hotel began life in 1785 as the much smaller Bailey's Hotel. The present building dates from 1900, following extensive alterations, and was renamed Hotel Metropole. Requisitioned by the government in 1939, it was subsequently bought back and again became the Metropole Hotel. Between 1955 and 1998, it was a Butlins Hotel before being sold again and renamed Grand Metropole Blackpool.

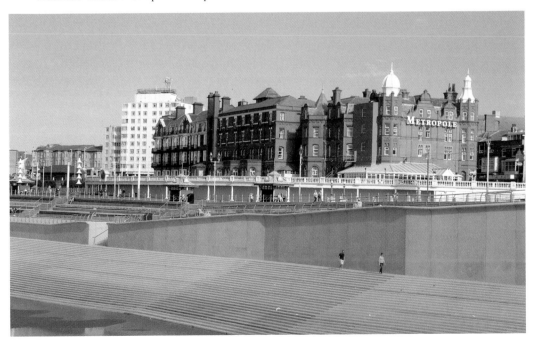

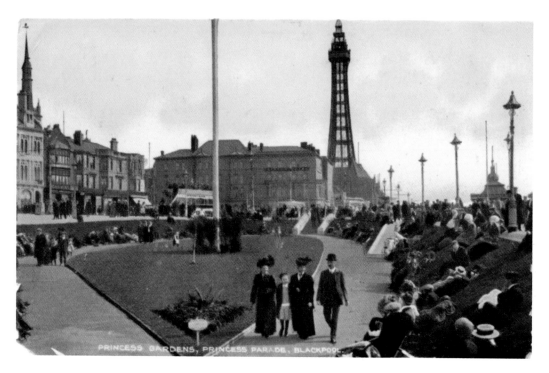

War Memorial

In this 1917 postcard view, we look back from north to south, past the front of the North Pier to the right, and Talbot Square with the Clifton Hotel on the corner to the left. This area is still named Princess Parade and Gardens. The town's war memorial obelisk was erected in 1923, where the flagpole stands in the old picture. To the right of today's image is the memorial plaque to the wreck of Nelson's flagship, the *Foudroyant*.

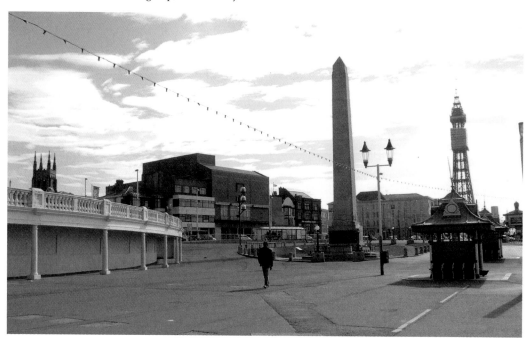

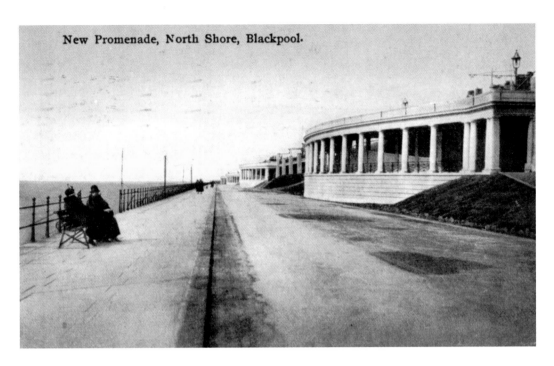

New Promenade, North Shore, Blackpool.

Paths and Promenades

Blackpool's ongoing improvements, as shown by the recent promenade work, almost pale when one considers the amount of work done at the north end of the town. Here, cliffs extended as far as Bispham. The work done from the early twentieth century into the late 1920s made the cliffs accessible via new paths and promenades, and even created two and three tiers of promenade, as shown here in this late 1920s view.

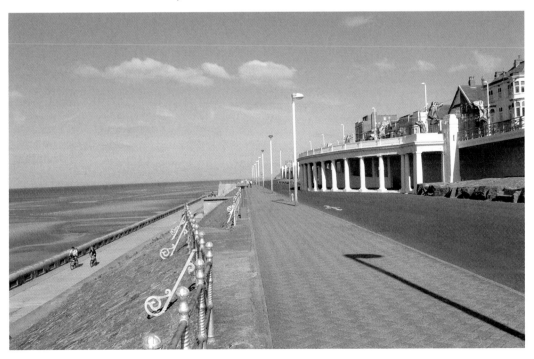

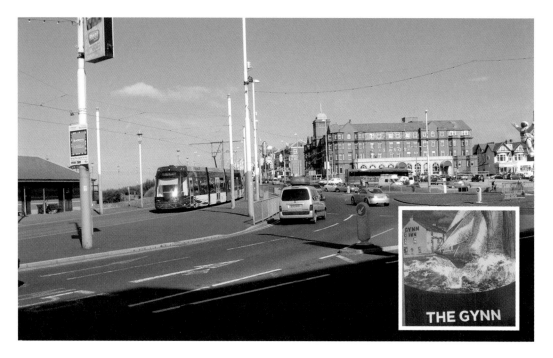

The Gynn

'The Gynn' now generally refers to a square and tram/bus stop. Its origins suggest that an inn was located here in the early 1800s or earlier. The building shown on the 1911 image survived until 1921. It was demolished during a road-widening project and the licence of the inn was transferred to a nearby hotel. The old inn stood where the traffic roundabout on the right of today's image now stands. A new hotel close to the site still bears the name. The Savoy Hotel is on the right of today's image.

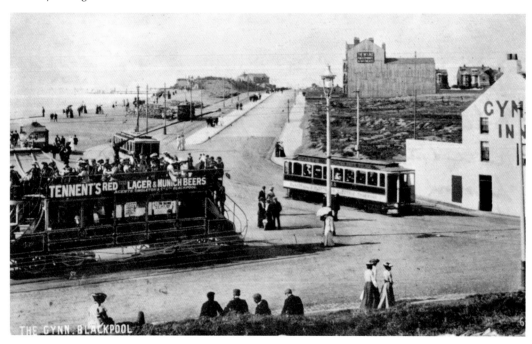

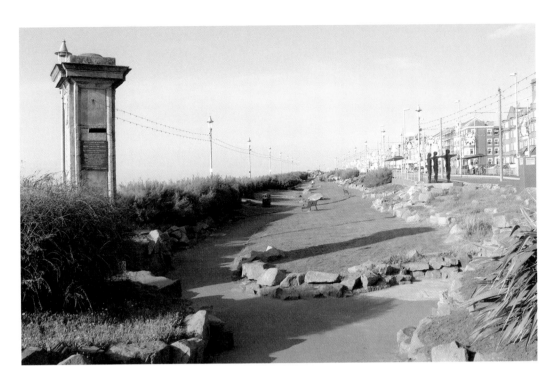

The Sunken Gardens

The Sunken Gardens, just past Gynn Square, wind their way between the cliff-side walkway and the road/tramway. Today, they are called the Jubilee Gardens, and have very attractive floral displays during the season. The south end of the garden nearer to the square originally had a pair of stone columns at the entrance. There is now only one. This bears a plaque commemorating the deaths of three police officers, who were drowned in a sea rescue attempt.

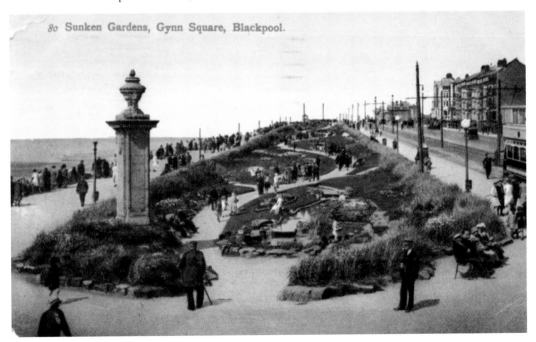

80 Sunken Gardens, Gynn Square, Blackpool.

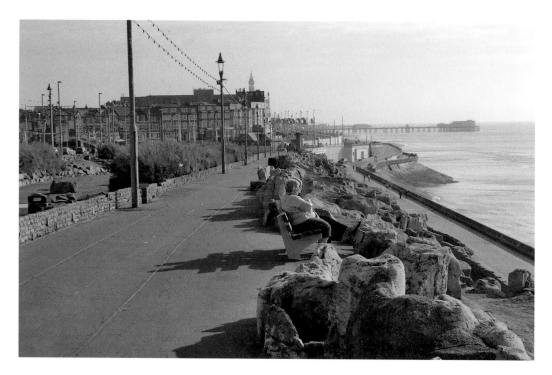

Rockery Promenade

As part of the improvement works carried out on the north shore cliffs, a clever feature was created in the form of stepped rock facing on the steep cliffs, which were not stable to begin with. The pieces of rock used were brought to the site and are not pieces of the original rock face. Large pieces of limestone form a sort of barrier to the steep Rockery Promenade footpath. This location is a favourite spot to sit, perhaps with a picnic overlooking the sea, as depicted in today's view.

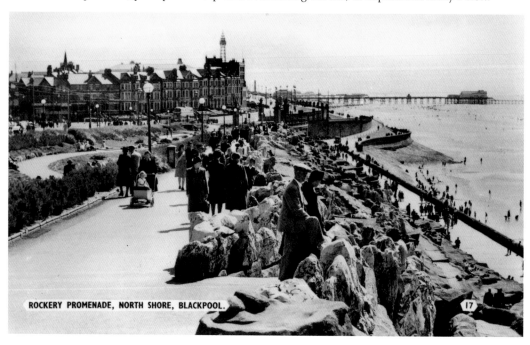

ROCKERY PROMENADE, NORTH SHORE, BLACKPOOL. 17

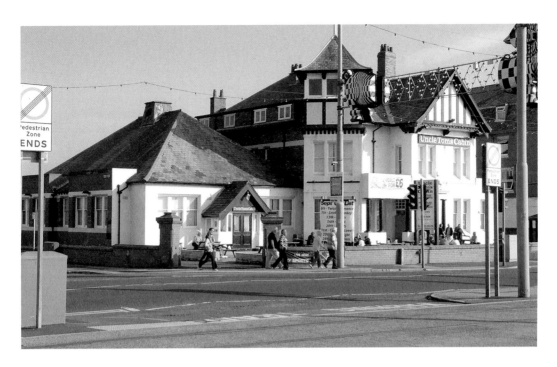

Uncle Tom's Cabin

Uncle Tom's Cabin is a name familiar to visitors as a place to go for an evening's drink and entertainment. It began life in the 1860s as a humble inn providing refreshments; the original cabin fell into the sea in 1907. It was close to what were eroding cliffs on north promenade. Although originally on the seaward side of the road, the hotel is now on the east side of the road. The present building dates from the early twentieth century.

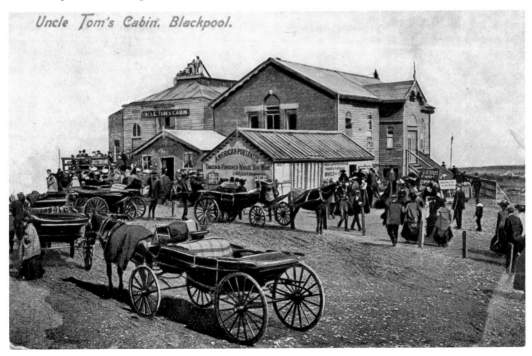

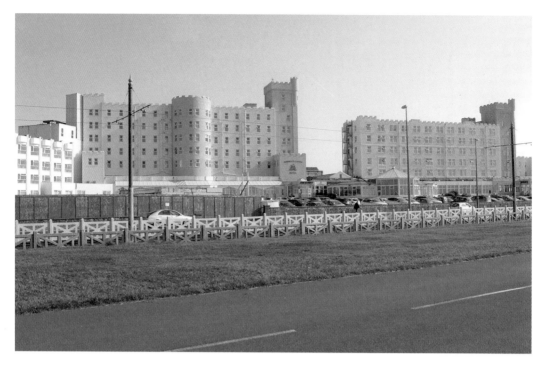

The Norbreck Castle

Norbreck Castle Hotel is one of Blackpool's most memorable buildings, its castellated walls giving the impression of battlements. Its origins are in the 1860s, when a country house began hosting visitors, and later became the Norbreck Hydro. By the 1930s, it was host to stage, screen and radio celebrities. The 1940s to 1950s saw it under government control, before its return to use as a hotel. Today, the hotel has 480 rooms, the largest hotel in the resort.

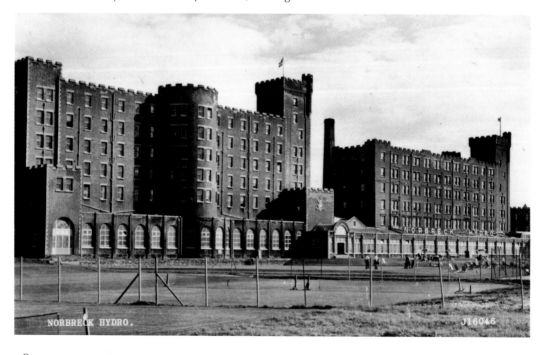

NORBRECK HYDRO.

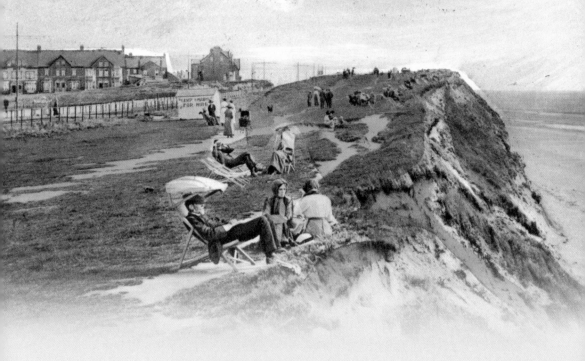

CHAPTER 4

Bispham to
Fleetwood

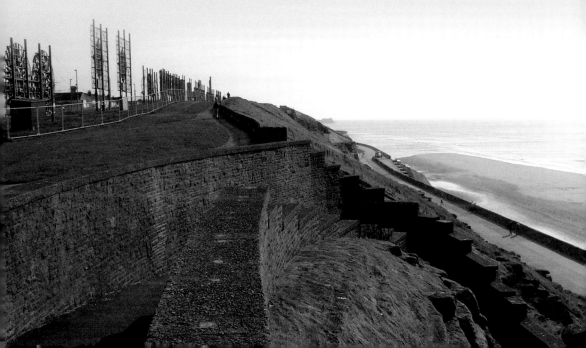

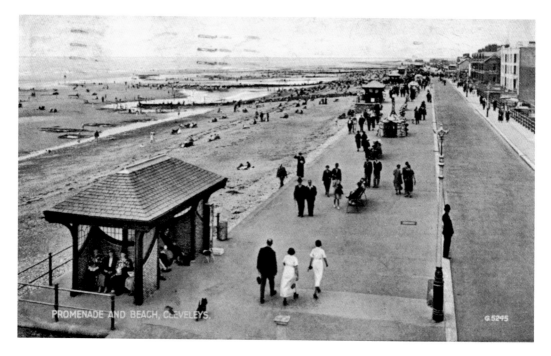

PROMENADE AND BEACH, CLEVELEYS. G.5245

Cleveleys Beach and Promenade

A little further along the coast we come to Cleveleys, a place to spend a quieter holiday, perhaps! The beach is wide and tidal, so sandcastle making is good for the younger visitors. The promenade gardens are a popular venue, adjoining the wide walkway overlooking the sea. The promenade is currently being upgraded with sculptures that have local associations. The town had its first hotel, then called the Hydro, with a Palm Court orchestra in 1902; it is now gone and the site has been redeveloped.

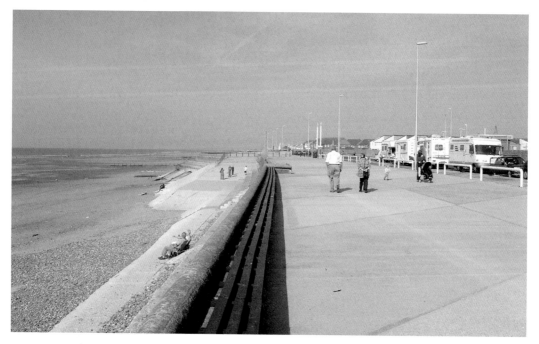

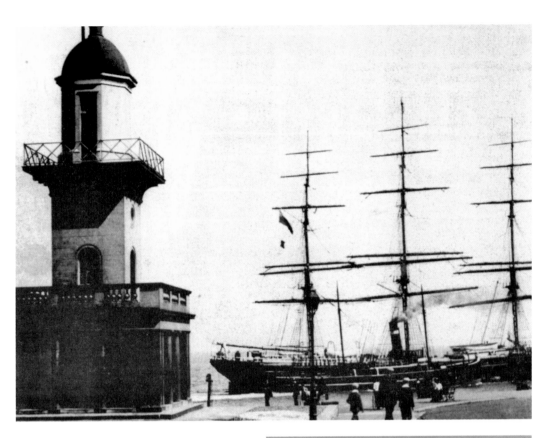

Fleetwood in Wyre

After passing through Rossall, with its famous school and new iconic observation/information tower by the shore, we arrive in Fleetwood. The town was best known for its fishing fleet, but this is sadly a thing of the past. Fleetwood had a railway terminus for passengers embarking on vessels to the Isle of Man, the last regular ferry sailing in 1961. This rail link no longer exists, but the town still has many associations with seafaring. The old lighthouse, called Lower Light, was one of two lighthouses used to guide vessels through the channel and into the dock. There is also a Maritime Museum near the ferry terminal.

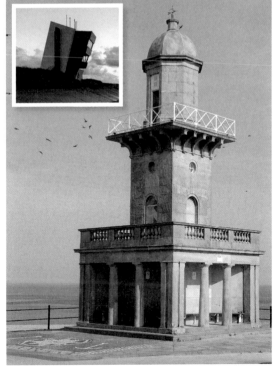

A Fishing Fleet

These fishing boats in dock provide a scene that gives us some idea of what used to be, when families lined any vantage point to wave a goodbye or a hello to the returning fishermen. Today, the dock is used as a marina for pleasure activities. It also hosts a trawler, now preserved, which is undergoing restoration. I believe the weather vane of today, made as a trawler silhouette, is appropriate to accompany the old fishing boats, and I have used it for today's image.

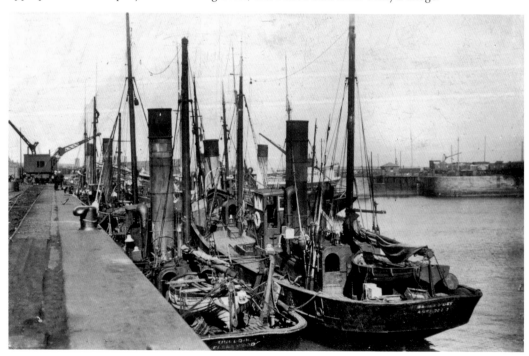

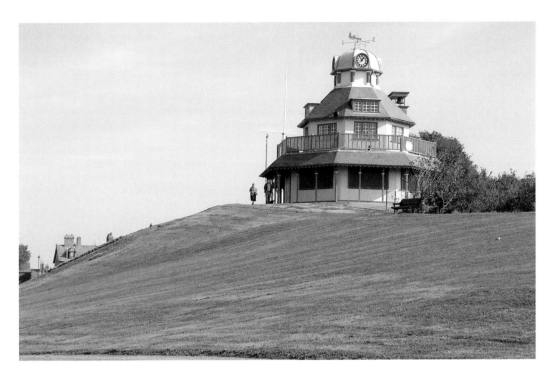

An Observation Point

The Mount is a large hill rising above the west side of the promenade and overlooking the esplanade, beach and sea. Originally, the town's street plan radiated from it. The Mount is a splendid vantage point for photography. The building atop this oddly situated hill has seen a varied life, from observation/weather station, to look-out point, souvenir shop and museum. The hillside itself is extensively used as a picnic area, but the building sadly seems to have fallen out of use.

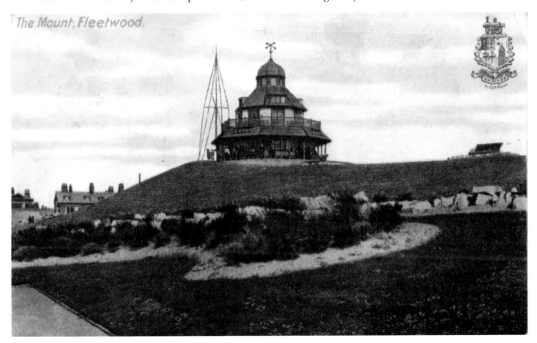

The Mount, Fleetwood.

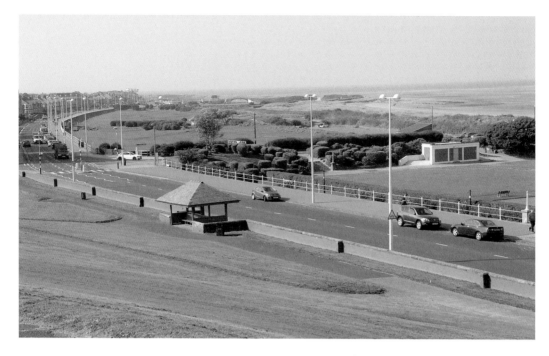

Vista From The Mount

Looking south-west from The Mount, we look over the esplanade with its green areas and walkways adjoining the beach. The curving road runs down toward Rossall, and beyond to Blackpool some 12 miles away. To the right are bowling greens in the Marine Hall gardens. There is a good beach, which is popular today with kitesurfers. The wide walking area next to the beach is also a cycleway, which runs down the coast.

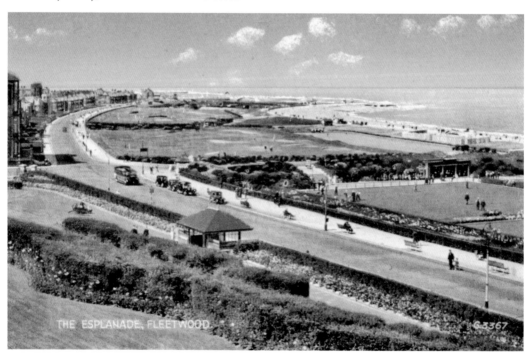

THE ESPLANADE, FLEETWOOD.

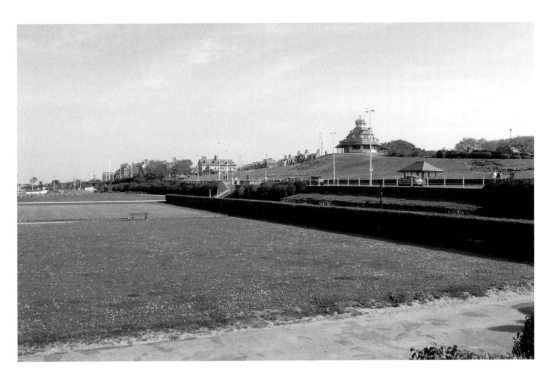

Look Back to The Mount

Looking back to The Mount from the Marine Pavilion, one can see the oddity that is the hill and building, and the reason for it being used for observation/weather. To the left of the old image, the road curves around the corner to arrive in the town itself where, on clear days, a magnificent view of the Lake District hills can be seen across Morecambe Bay.

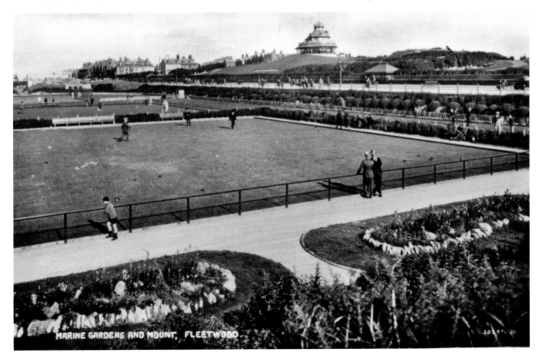

Marine Pavilion Gardens

The Marine Pavilion Gardens have recently been upgraded. The bowling greens, still well used, have been reduced in number by one. The gardens with their attractive floral displays are another feature to see, and they attracted many Red Admiral butterflies this year. The new curving stonework features are almost Art Deco in places.

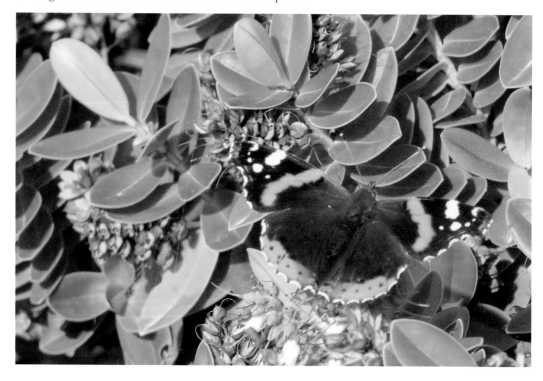

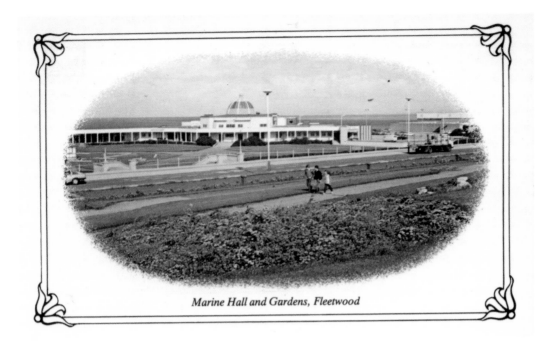

Marine Hall and Gardens, Fleetwood

Marine Pavilion

Viewed from the esplanade, the views here are of the front of the 1935-built Marine Pavilion itself, a concert venue that has hosted so many celebrities over its lifetime. Perhaps giving the greatest pleasure to local people recently was Alfie Boe, one of Fleetwood's sons and one of the country's well-loved opera singers, who has produced many albums and has performed on many stages, including in his home town.

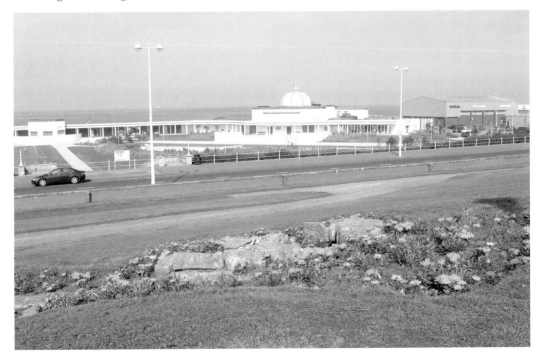

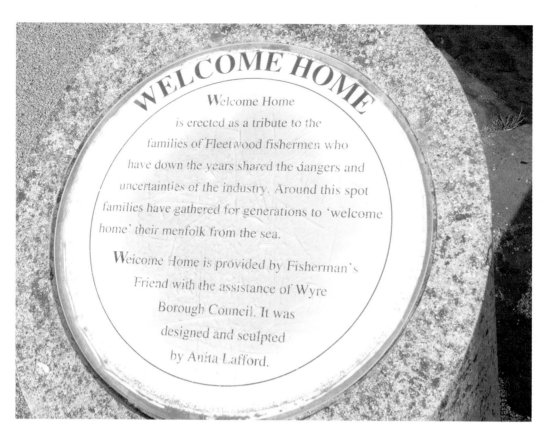

WELCOME HOME

Welcome Home
is erected as a tribute to the
families of Fleetwood fishermen who
have down the years shared the dangers and
uncertainties of the industry. Around this spot
families have gathered for generations to 'welcome
home' their menfolk from the sea.

Welcome Home is provided by Fisherman's
Friend with the assistance of Wyre
Borough Council. It was
designed and sculpted
by Anita Lafford.

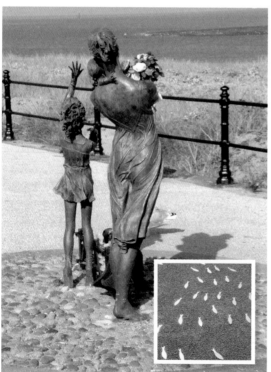

Welcome Home

The 'Welcome Home' statues on the promenade, opposite the North Euston Hotel, face the River Wyre channel. The sculpture shows a mother with a baby and a small child, looking for and waving to the husband/father on his return from fishing. Many Fleetwood men were lost during fishing trawler voyages. The statue embraces both sadness and joy for the families affected. Often flower bouquets are laid beside the figures. The surrounding footpath has within it metal fish, as if in shoal. There is no old image of this recent work. The plaque (*and inset*) is of interest.

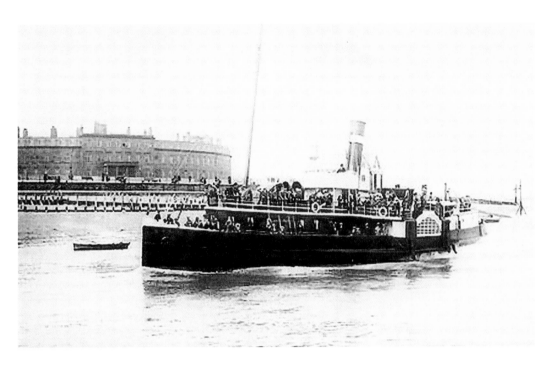

North Euston Hotel

Across the promenade from the previous sculpture work, we look over a wide lawn to the frontage of the North Euston Hotel. The hotel is so called because it was envisaged that transitional passengers to the ferries would stay here, perhaps after a long journey from London Euston. Perhaps they did, but the hotel is 'in your face', as they say, and always seems busy with functions and musical events, as well as being a good place to stay.

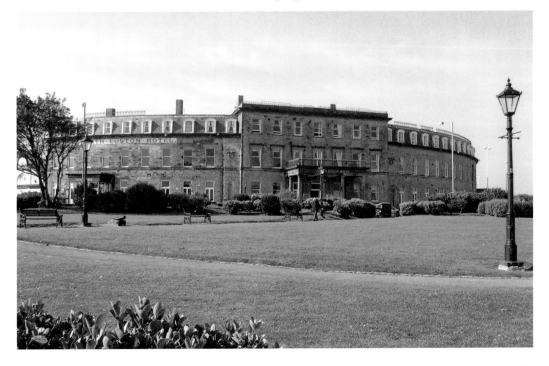

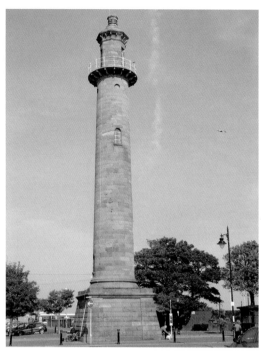

Pharos Light

The other lighthouse in Fleetwood town is this sandstone structure called the Pharos Light. Our two views here show the building from two locations along different streets. The old view shows the open-topped 'boat' tram of 1934 vintage, still in service during the season. However, the older trams will not be regularly used on the journey to Fleetwood, but will be in use on Blackpool Promenade.

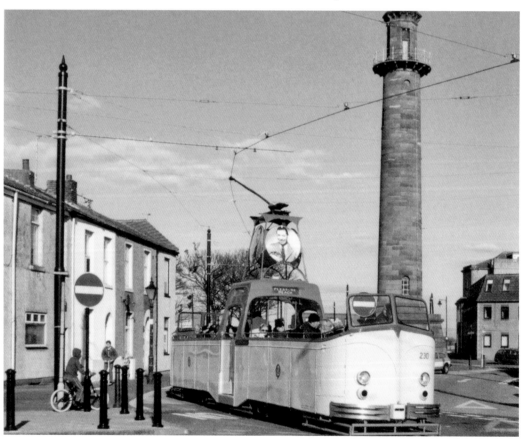

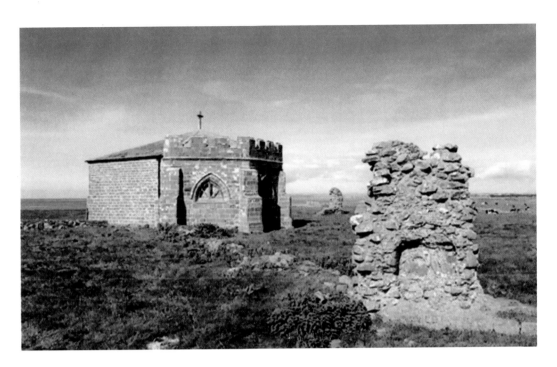

Cockerham

Across the River Wyre Estuary lies Knott End, approached from Fleetwood by ferry, or by crossing inland over Shard Bridge. A few miles up the coast lies Cockerham township, with the remains of Cockersands Abbey close by. Founded pre-1184 as the Hospital of St Mary on the Marsh, the abbey was dissolved in 1539. All that remains today is the vaulted Chapter House, dating from 1230. This is a Grade I listed building.

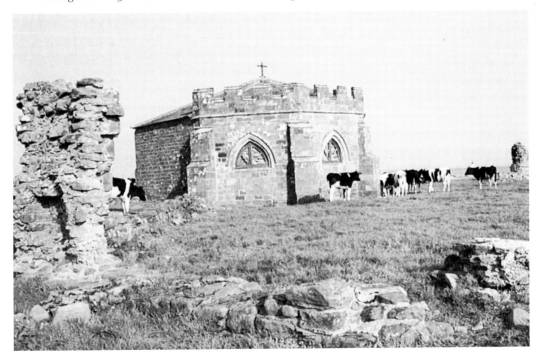

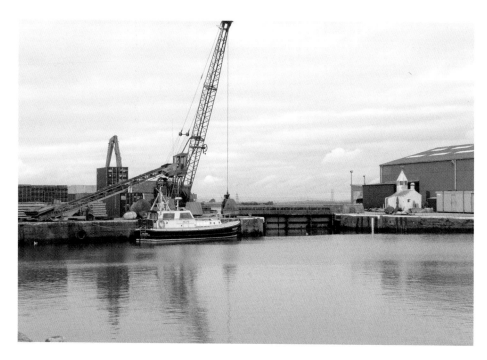

Glasson Dock

Lancaster was a port from early times. Silting of the River Lune led to the 1787 creation of a separate port at Glasson, a few miles south-west. It meant that goods had to be transferred from ships to carts initially, then to their respective destinations. The building of the Lancaster Canal (Lancaster to Wigan Coalfields) in the same decade, led also to the building of a branch to Glasson Dock. A view of the sea dock, which was used by trawlers, with a lock gate to the River Lune is shown in both images.

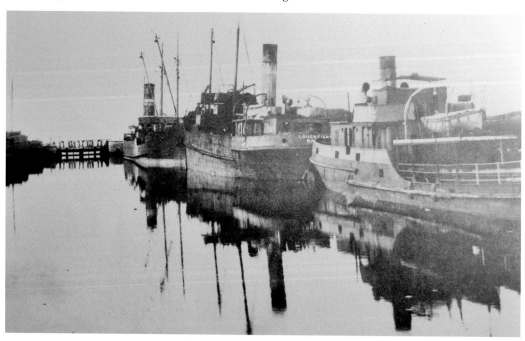

Glasson Basin

Still in Glasson Dock, here we look across the inner basin, separated from the sea dock by another lock. Today, this basin is mainly used as a marina for canal boats and cruisers, smaller seagoing vessels such as yachts and occasionally even cruiser-type vessels! Glasson Dock is certainly worth a visit, with its interesting locks and basins, a variety of vessels, two hostelries for refreshments and artefacts from old vessels, including the anchor from the Isle of Man boat, the *King Orry*.

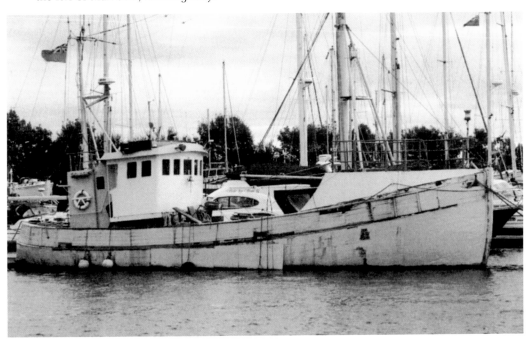

Glasson Canal Locks

The Glasson Dock branch of the Lancaster Canal gives access in and out of the inner basin at Glasson Dock, and runs for some 4 miles, passing through several sets of locks, to join the main canal system. In commercial days, the dock and canal were extremely busy with boats, loading or unloading, then traversing the branch with their cargoes. The canal basin is now a popular mooring place for boats on holiday, making it a centre from which to travel around the area.

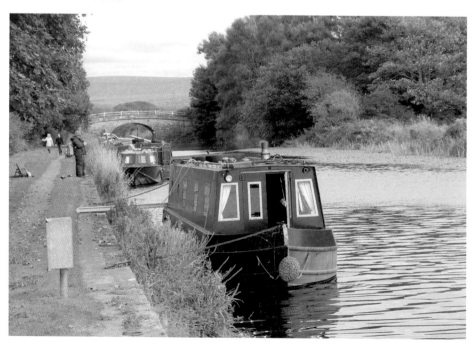

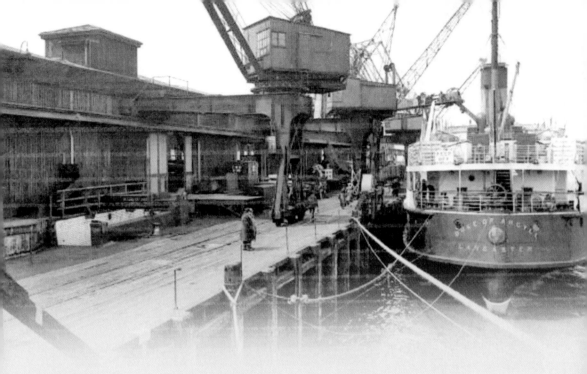

CHAPTER 5

Heysham, Morecambe & Lancaster

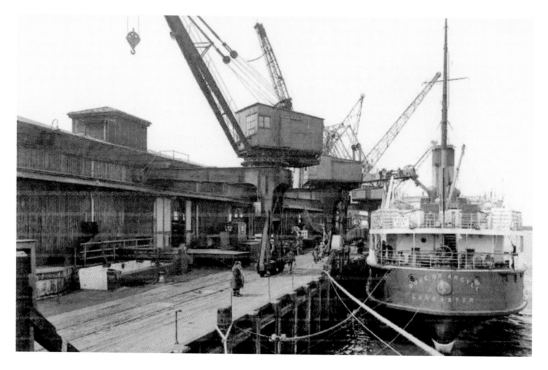

Heysham Harbour

Moving north from Glasson, passing Sunderland Point, we arrive at a conurbation that has two large, dominating buildings. These are the Heysham Number One and Two nuclear power stations, located in the dockland area. A short distance away is the ferry terminal for the Isle of Man. Commercial vessels, a railway system and the usual configuration of a busy dock system, prove that Heysham Harbour is busy, apart from the traffic to and from the power stations.

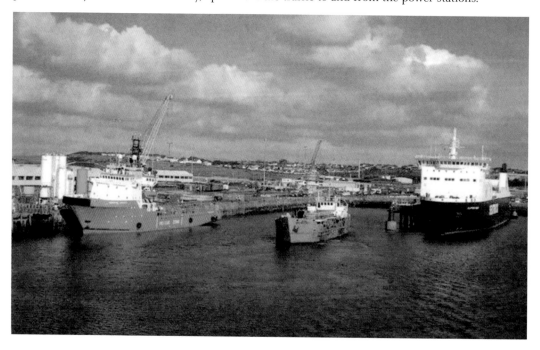

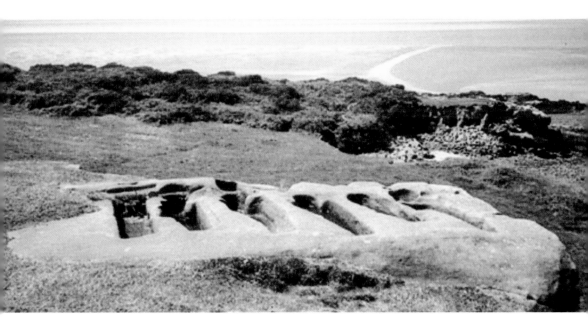

Rock-Cut Graves

Heysham has a contrasting history. Overlooking the nuclear power station is Heysham Head, on which graves are cut into the rock. These graves are on a slab of rock close to the cliff edge. It is believed that the graves are Saxon, but no artefacts have been found in them. They appear to have been covered by stone slabs when the burials took place. Excavations nearby have yielded items from the Norse and Saxon period.

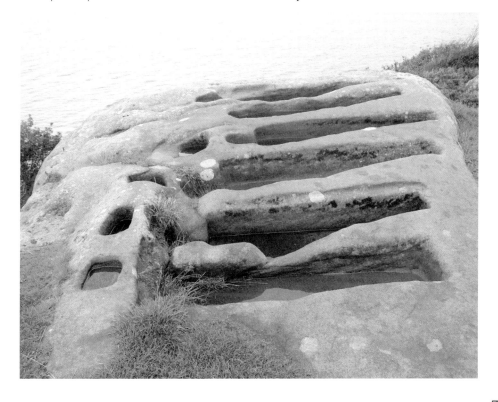

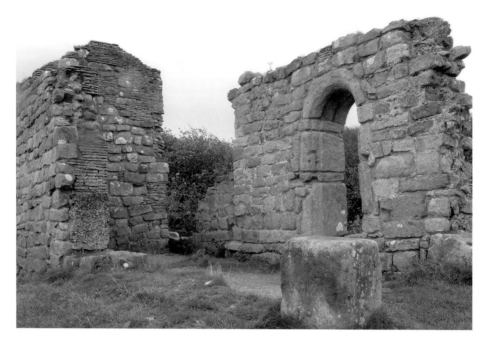

Saxon Chapel

Close to the rock graves, on this high, windswept promontory, a small chapel dedicated to St Patrick was built in Saxon times. Excavations here have yielded Norse and Saxon related items. Today, some remaining walls of the chapel are restored. The old view, taken from the village shoreline, looks at Heysham Head. The chapel walls are visible on top of the hill. Today's view was taken inside the chapel ruins.

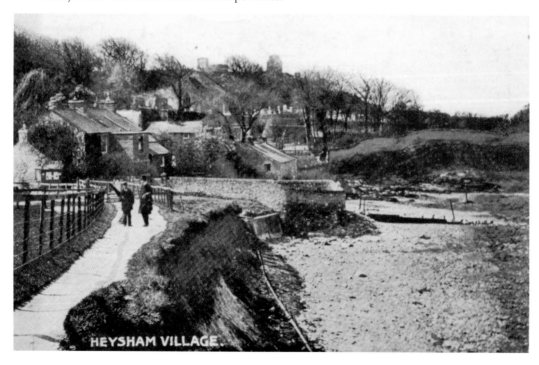

HEYSHAM VILLAGE.

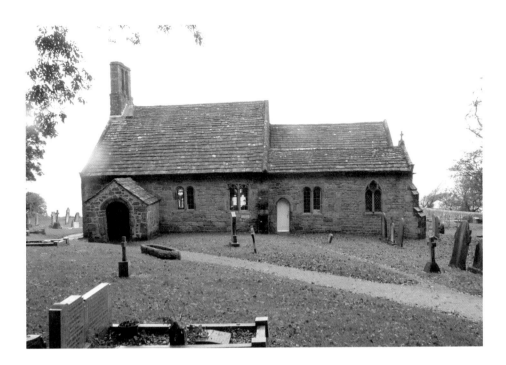

Heysham Head Church

Heysham Head, apart from its quaint streets and famed nettle beer, is probably best known for St Peter's church. This building is one of great age (around tenth century), as is its predecessor on the headland above, overlooking the sea. There is evidence of Norse occupation in the area. There is a carved gravestone with typical Norse decoration – shaped like a hog, hence 'hogback stone' – which was at one time in the graveyard and is now protected inside the chapel.

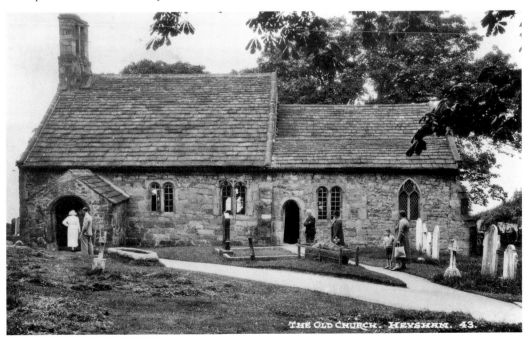

THE OLD CHURCH. HEYSHAM. 43.

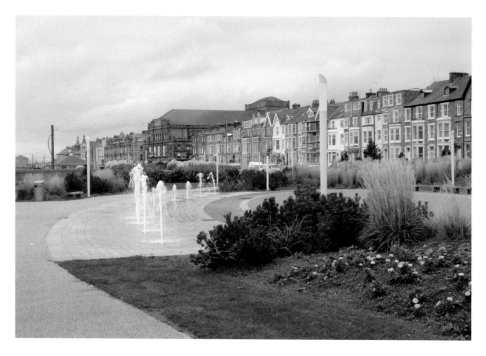

Morecambe

Morecambe is next on our itinerary, and one moves from 'history' to 'holiday' mode between Heysham and Morecambe. Entering the town from the south, one is struck by bird statues on traffic islands. Arriving via Heysham Road, one is immediately on the esplanade, with the seashore to the left, across wide walkways and grassed verges. Little has changed here from our old view, except that the glass shelter has been replaced by fountains.

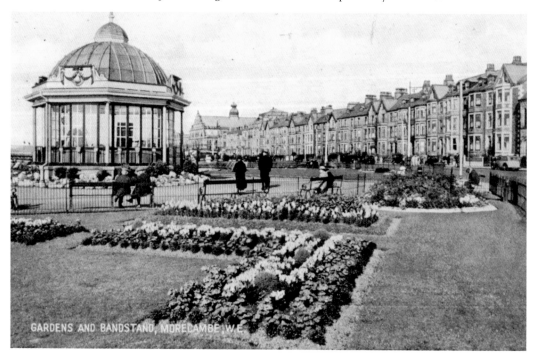

GARDENS AND BANDSTAND, MORECAMBE, W.E.

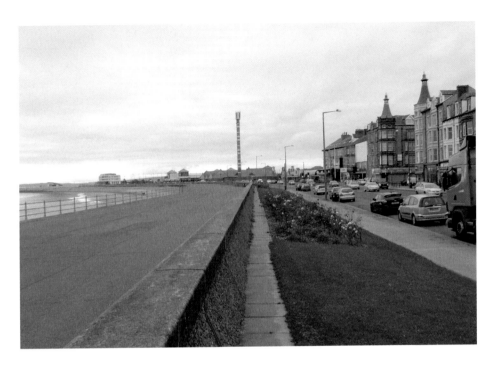

Esplanade

A little further along the promenade, the old view shows a high tide. Today, the sea and beach is mostly hidden by a sea wall. Yet with many sets of steps, the beach is easily accessed. The modern image shows how wide the whole esplanade is from buildings to sea wall. A large number of the buildings on the right-hand side of the images are shops, interspersed with hotels. Many are currently undergoing refurbishment.

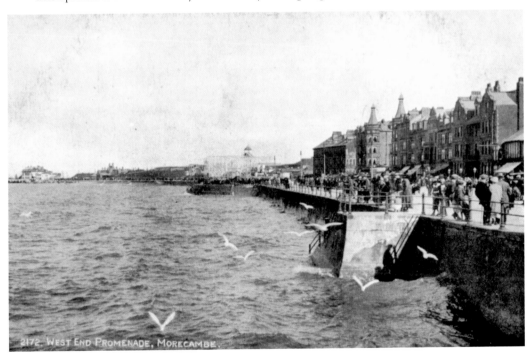

2172. WEST END PROMENADE, MORECAMBE.

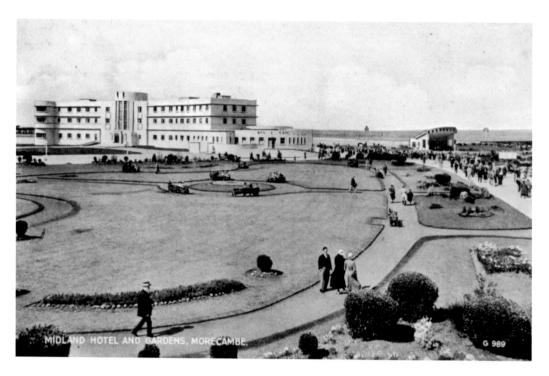

MIDLAND HOTEL AND GARDENS, MORECAMBE.

G 989

The Midland Hotel

The Midland Hotel is one of Morecambe's special hotels. Built in 1933 by the LMS Railway, its Art Deco architecture style is still proving to be a great attraction. The hotel is used often for period dramas on television, such as the *Poirot* series. It has recently undergone refurbishment, and is always a special place to visit, even if it is just for tea. It is unfortunate that some of the original fittings and fixtures of the period are no longer in place. The whole building is an icon, inside and out, and a joy to photographers and lovers of this period architecture.

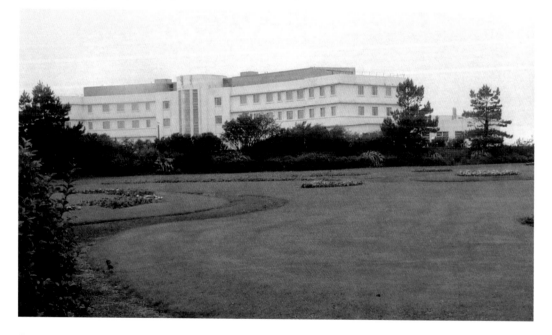

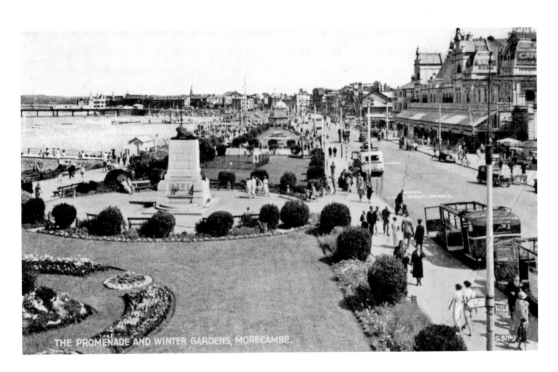

THE PROMENADE AND WINTER GARDENS, MORECAMBE.

War Memorial

Approaching the central promenade, the Morecambe and Heysham War Memorial is to the left, across the road from the famous Opera House, which sadly is no longer in full use, but at least it is open again, and ongoing refurbishment by a dedicated team of volunteers is taking place. Across the road from the building was a pier called West End, lost due to a storm in 1978. In the old postcard dated 1938, the Opera House seems to be busy, with many adverts for the seasonal entertainments. The memorial commemorates the local men who died during the First and Second World Wars and the Korean War.

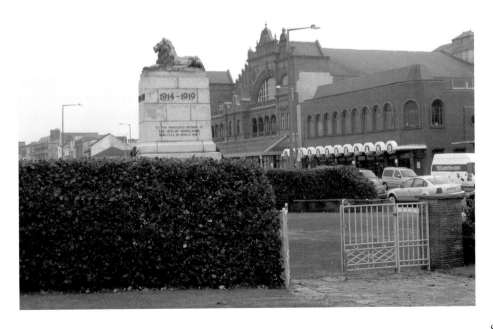

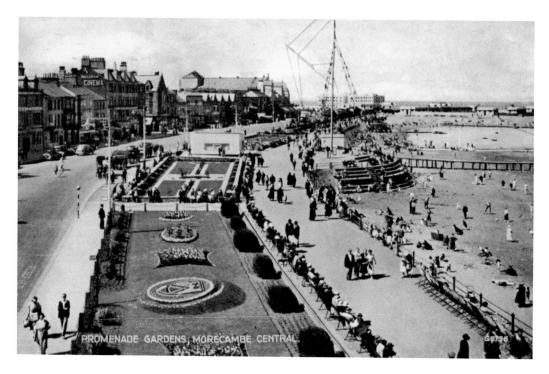

Promenade Gardens

The Promenade Gardens looking back to the west end. In the distance is the Midland Hotel and West End Pier, with the Opera House to the centre left and the beach to the right side. Across this is one of the walkways for people to walk out to the boats for a sail, and get back in time for tea. It is unfortunate that some of the former Promenade Gardens have been made into car parks.

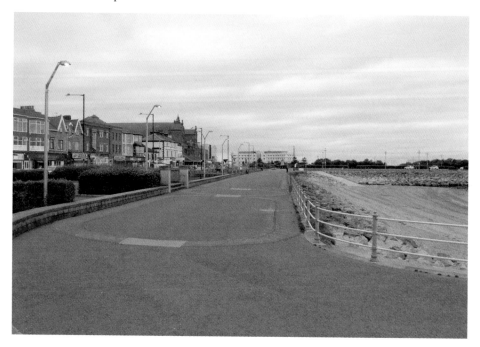

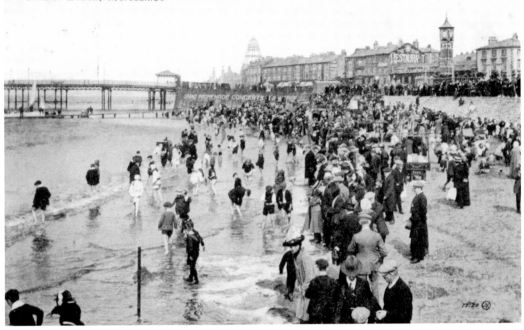

Central Beach

Central Beach in 1915, according to the postcard image. Notice the clothes worn by the people: not a costume in sight, nor a 'bathing machine hut'. In fact, there are very few bare legs to be seen, even those paddling in the sea. Note the clock tower of 1905, which is still in place, while the Central Pier, evident in the old view, is gone. It was built in the late 1860s and had a jetty where steamers docked. It also had a pavilion described as the 'Taj Mahal of the North'.

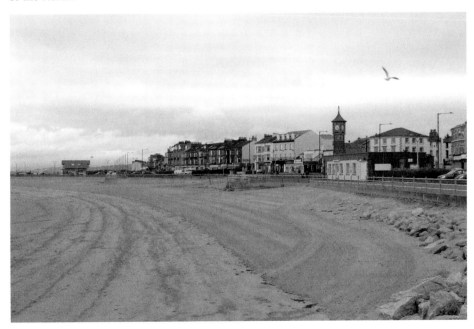

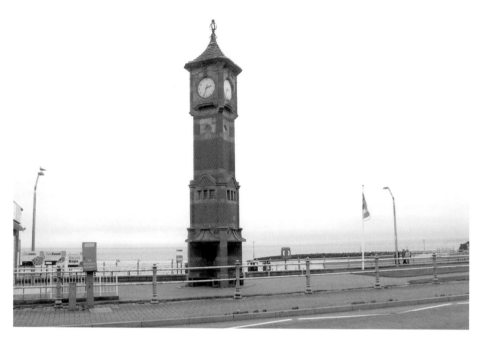

Central Pier and Pavilion

Another view of the pier shows the magnificent pavilion described on page 85. It was a place for dancing and varied entertainments. Burned down in 1933, a new ballroom was built in place of the old building. This venue served the community well, especially in the war years when it was popular with servicemen. After some years of closure, a refurbishment proposal was made to restore it. However, another fire destroyed the timberwork and the pier was demolished.

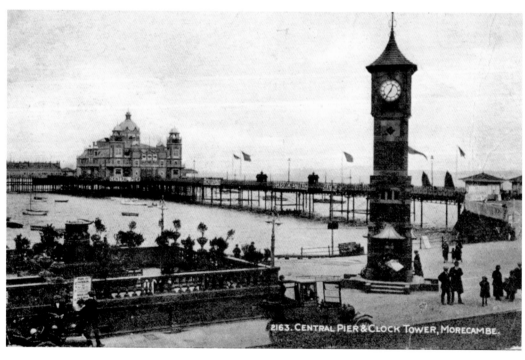

2163. CENTRAL PIER & CLOCK TOWER, MORECAMBE.

Lancaster Folly

The Ashton Memorial in Williamson Park, Lancaster, was built between 1907 and 1909, and is described as 'England's grandest Folly'. It was built by Baron Ashton in memory of his family, costing in the region of £80,000. The monument is 150 feet tall, built in the English Baroque style, using Portland stone. A fire damaged it in 1962, and it was closed for safety reasons in 1981, but restored in 1987–89. Today, it is used for weddings and concerts. It is allegedly near to the mathematical centre of the United Kingdom.

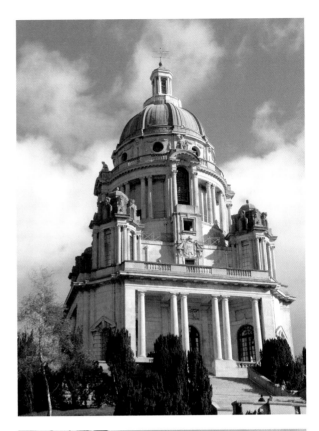

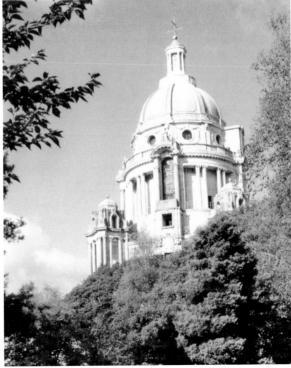

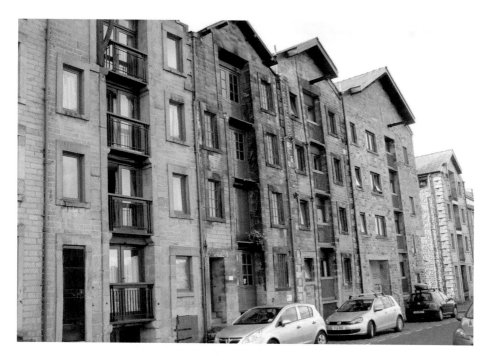

Customs House

Lancaster is a few miles inland from the coast, yet its shipping associations are still prevalent. Lancaster is a historic city with physical evidence of a Roman garrison. Its association with shipping began several hundred years ago. During the eighteenth century, improved docking and storage warehousing was created. Today, the river quayside still has many three-storey warehouses dating from the 1750s, and a customs house, now a Maritime Museum. Some of the old buildings have been newly built, yet styled to look like the original warehouses next to them.

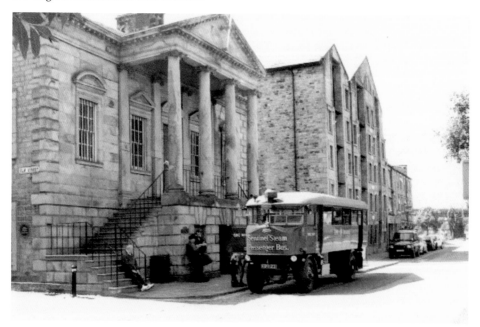

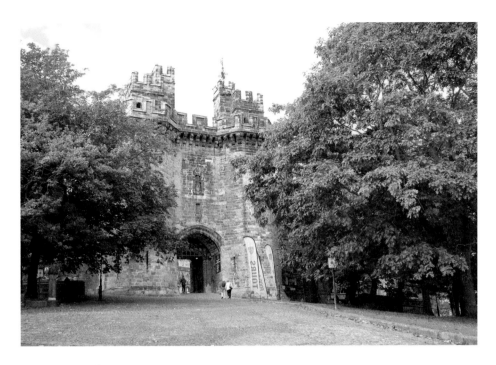

Lancaster Castle

Lancaster Castle dates from the twelfth century, and was built on the site of a Roman fort. It was established when the Duchy of Lancaster came under Royal control. In 1389, the Scottish raids damaged the castle, and it was besieged during the Civil War in 1613. The trial and execution of the Pendle Witches took place here in 1612. The photographs show the main entrance, John O'Gaunt's Gate, which was rebuilt in the early 1500s. The general public have restricted access to the castle.

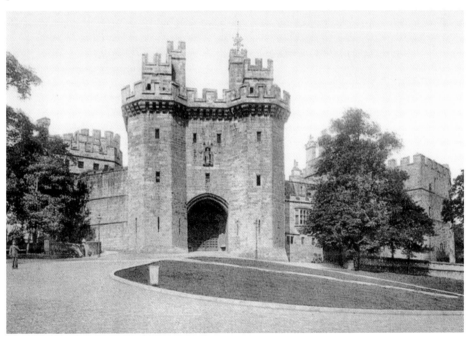

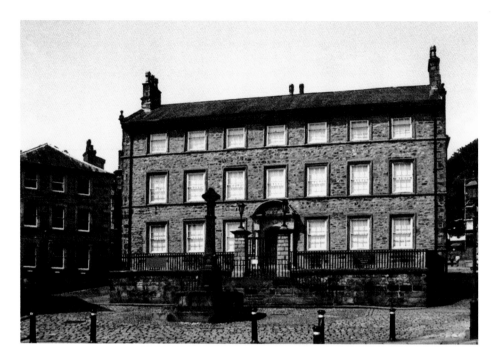

Judges Lodgings

The Judges Lodgings, Lancaster, is so called because it was the accommodation at which assize court judges would stay during their visits. The building is Grade I listed. The present building was built in 1625 on the site of a previous house. A Roman kiln was found in the garden of the house. Mayors of Lancaster and the Keeper of the Castle have lived in the house. It is open to the general public and is used as a museum.

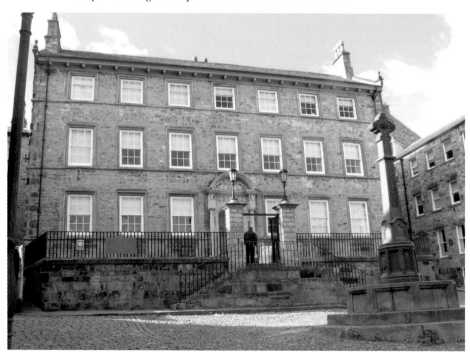

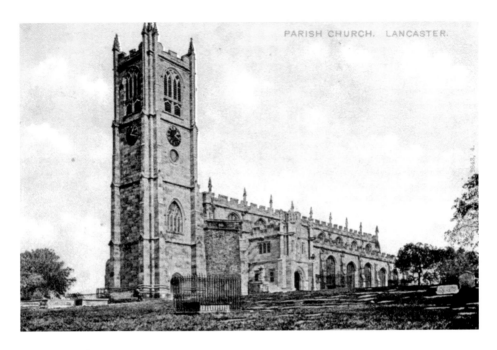

Lancaster Priory

St Mary's church, or Lancaster Priory (since the 1930s), was founded in 1094 by Roger of Poitou. The priory was used by monks of the Benedictine Order, who were subordinates to the Abbot of St Martin's Abbey at Sees, in Normandy. The church is described as being the finest example of a medieval church in Lancashire, and stands on the site of the first monastery in the county. A must-see are the fourteen choir stalls brought here from Cockersands Abbey. The old view of the south side of the church is now partially covered by trees.

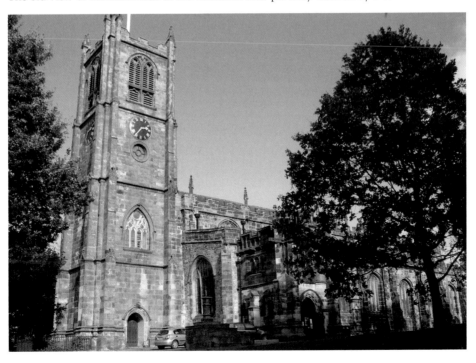

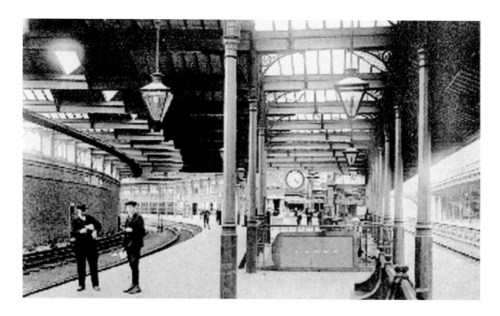

Carnforth Station

Carnforth railway station has an interesting history: it has featured in a classic British film, *Brief Encounter*, which is still shown on television occasionally. The original nineteenth-century station has seen several makeovers and rebuilds during its lifetime. Today, on its stone frontage, below its name, is Visitor Centre. Despite Virgin Pendolinos thundering by, for it is on the West Coast main line, the platform clock and its tea room with its museum of memorabilia is frequently visited and photographed.

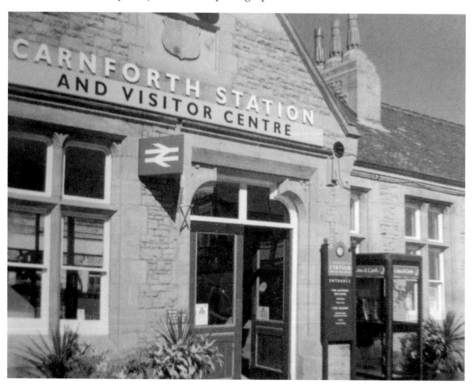

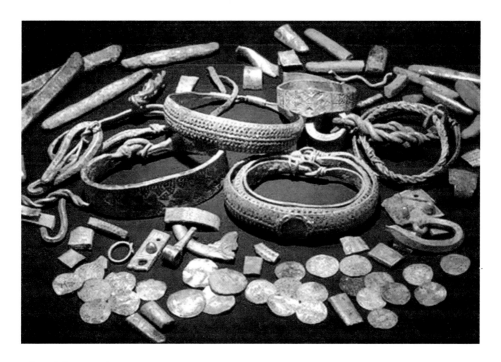

Silverdale Hoard

Almost 1000 years separate these images, yet they are both associated with Silverdale. Looking across the picturesque countryside, the 'Pepperpot' (a local nickname) is a feature to visit. This circular stone tower at Castlebarrow was built to commemorate Queen Victoria's Golden Jubilee in 1887. This scattered farming community, which has an interesting shoreline, has been the site of both copper smelting and boatbuilding in the past. The Silverdale Viking Hoard was probably buried during intense conflict between Anglo-Saxons and Viking settlers in around AD 900. The hoard, containing over 200 pieces of silver jewellery and coins, was discovered in 2011.

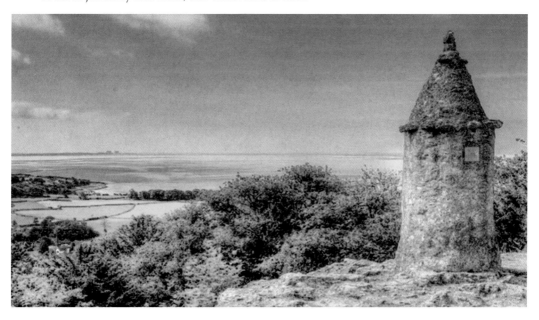

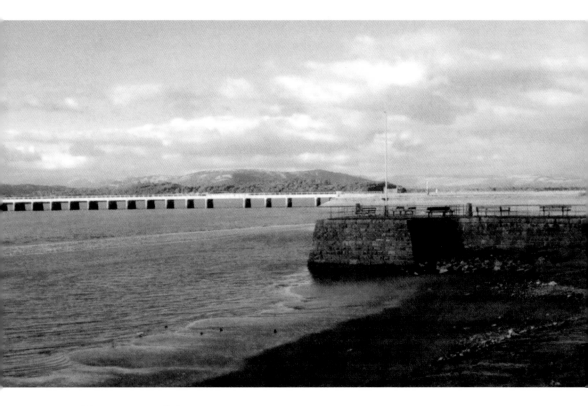

Lancashire Meets Cumbria

We are now leaving Lancashire behind, for we are officially in the county of Cumbria, and the village of Arnside. Despite this, as the village is so close to Lancashire, I think we have adopted it as part of the county. After all, most residents speak with more of a 'Lanky Twang' than a Cumbrian accent. Arnside was a small port during the eighteenth and nineteenth centuries, and it busied itself with fishing and shellfish sales. The distant viaduct was largely the reason for the construction of the 'compensation' stone pier, as described on the next page.

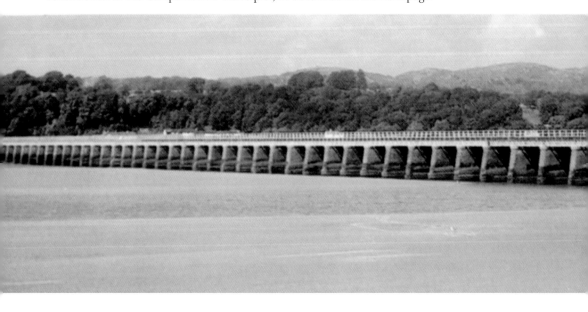

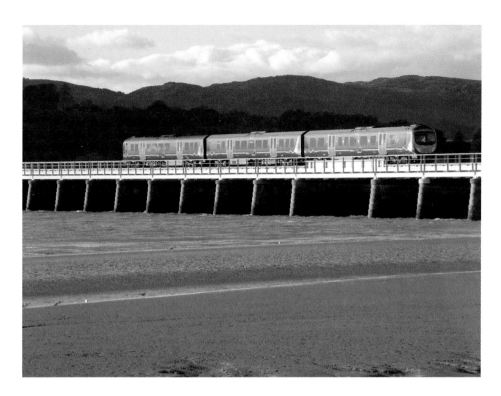

Arnside Railway Viaduct

Just outside the railway station, the railway crosses the wide and hazardous River Kent on a 1,300-foot-long viaduct. It has forty-six arches, with piling driven into 70 feet of sand below the river. The viaduct stopped the shipping trade to Milnthorpe. As compensation, a short, stone pier was built by the Ulverston & Lancaster Railway Company. Goods unloaded at Arnside and nearby Sandside included sugar, salt, flour, rum, sacking, and hemp.

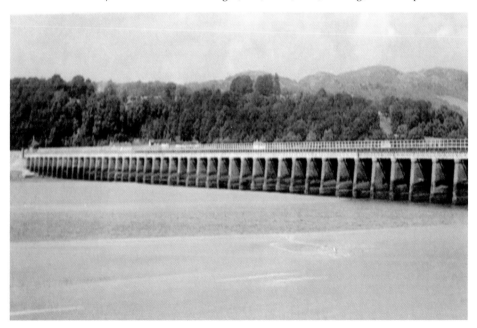

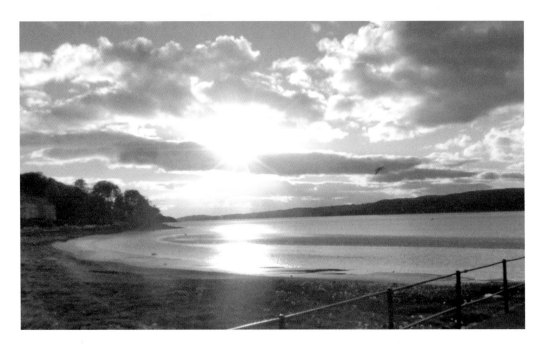

End Of Day
This glorious sunset was seen from Arnside in October 2013. The view looks west towards the River Kent Estuary and the sea. Just visible is the stone pier. The journey along the west coast of our reduced administrative county ends here. The distance is not too great, but the places of interest, from seaside to sand dunes and rivers to railway stations, plus interesting scenery along the way, are plentiful and far too many for this small volume to discuss in detail. So, enjoy the exploration!

Acknowledgements

In compiling this volume, I have had the help and advice of those listed below, as well as those writers before me, and my contemporaries, whose dates and information have spurred me along. I would like to thank them, and the many producers of the simple postcard, for their old recorded images and nostalgia.

Thank you to the officers and employees of many local townships I visited; to the staff of boatyards at Tarleton and Hesketh Bank for access; to the library staff in several towns visited for their help. Thanks also go to the following individuals: J. Anderton, G. Allsopp, Mr and Mrs A. Bridges, Mr and Mrs G. Corns, D. Baines, H. Brindle, J. Davenport, H. Edwards, Mrs M. Rawlings, Mr and Mrs J. Monks, Mrs D. Firgarth, and Mr and Mrs B. Holding. Last but by no means least, thanks go to my partner Barbara Morgan for her computer knowledge and support.

A very big thank you to all concerned.